NICA

THE JESSIE AND JOHN DANZ LECTURES

*The Jessie and John Danz Lectures*

*The Human Crisis,* by Julian Huxley

*Of Men and Galaxies,* by Fred Hoyle

*The Challenge of Science,* by George Boas

*Of Molecules and Men,* by Francis Crick

*Nothing But or Something More,* by Jacquetta Hawkes

*How Musical Is Man?,* by John Blacking

*Abortion in a Crowded World: The Problem of Abortion with Special Reference to India,* by S. Chandrasekhar

*World Culture and the Black Experience,* by Ali A. Mazrui

*Energy for Tomorrow,* by Philip H. Abelson

*Plato's Universe,* by Gregory Vlastos

*The Nature of Biography,* by Robert Gittings

*Darwinism and Human Affairs,* by Richard D. Alexander

*Arms Control and SALT II,* by W. K. H. Panofsky

*Promethean Ethics: Living with Death, Competition, and Triage,* by Garrett Hardin

*Social Environment and Health,* by Stewart Wolf

*The Possible and the Actual,* by François Jacob

*Facing the Threat of Nuclear Weapons,* by Sidney D. Drell

*Symmetries, Asymmetries, and the World of Particles,* by T. D. Lee

*The Symbolism of Habitat: An Interpretation of Landscape in The Arts,* by Jay Appleton

# THE SYMBOLISM
## *of*
# HABITAT

## *An Interpretation*
## *of Landscape in the Arts*

JAY APPLETON

UNIVERSITY OF WASHINGTON PRESS

*Seattle and London*

Library of Congress Cataloging-in-Publication Data

Appleton, Jay.
    The symbolism of habitat: an interpretation of landscape in the
arts / Jay Appleton.
        p.   cm. — (The Jessie and John Danz lectures)
    Includes bibliographical references.
    ISBN 0-295-96940-7
    1. Landscape in art. 2. Nature (Aesthetics) 3. Arts—Themes,
motives. I. Title. II. Series.
NX650.L34A67 1990
700—dc20                                          89-24811
                                                      CIP

*To all my friends in the*
*Landscape Research Group*

# The Jessie and John Danz Lectures

In October 1961, Mr. John Danz, a Seattle pioneer, and his wife, Jessie Danz, made a substantial gift to the University of Washington to establish a perpetual fund to provide income to be used to bring to the University of Washington each year "distinguished scholars of national and international reputation who have concerned themselves with the impact of science and philosophy on man's perception of a rational universe." The fund established by Mr. and Mrs. Danz is now known as the Jessie and John Danz Fund, and the scholars brought to the University under its provisions are known as Jessie and John Danz Lecturers or Professors.

Mr. Danz wisely left to the Board of Regents of the University of Washington the identification of the special fields in science, philosophy, and other disciplines in which lectureships may be established. His major concern and interest were that the fund would enable the University of Washington to bring to the campus some of the truly great scholars and thinkers of the world.

Mr. Danz authorized the Regents to expend a portion of the income from the fund to purchase special collections of books, documents, and other scholarly materials needed to reinforce the effectiveness of the extraordinary lectureships and professorships. The terms of the gift also provided for the publication and dissemination, when this seems appropriate, of the lectures given by the Jessie and John Danz Lecturers.

Through this book, therefore, another Jessie and John Danz Lecturer speaks to the people and scholars of the world, as he has spoken to his audiences at the University of Washington and in the Pacific Northwest community.

# CONTENTS

*Preface*   *xi*

*Acknowledgments*   *xiii*

1.  SYMBOL, HABITAT AND THE AESTHETIC
    MYTH   *3*

2.  THE ANALYSIS OF LANDSCAPE AND THE
    SYMBOLISM OF OPPORTUNITY   *23*

3.  THE PROOF OF THE PUDDING   *71*

*Notes*   *107*

*References*   *109*

*Index*   *111*

# PREFACE

IN THE SERIES of Jessie and John Danz Lectures delivered at the University of Washington in February and March 1988, under the title "The Symbolism of Habitat: An Interpretation of Landscape in the Arts," I attempted to develop a single theme which, in order to fit the format of the program, had to be divided into three parts. Fortunately it proved possible to make such a division without doing violence to the continuity of the whole.

The format of a lecture is not necessarily the best format for a book, and certain changes are inevitable, especially when one has relied on the use of a large number of slides, not all of which can be reproduced. Nevertheless I have decided to follow the original text as closely as possible. Certain passages have had to be rephrased and others omitted, but I have made as few changes as possible.

The aim of the lectures was to extend the theme of a book called *The Experience of Landscape* (Appleton 1975), exploring its implications for symbolism, particularly as used in the arts. Some reference to the content of that book will be made in chapter 2, but only to the extent necessary for an understanding of the present argument. The earlier book drew on the ideas of the American philosopher, John Dewey, extending them specifically into the field of landscape aesthetics, a subject about which Dewey himself had relatively little to say. The idea that it is legitimate to look for the origins of aesthetic values in other fields of experience, such as may be found in the biological and behavioral sciences, has caused a strong divergence of opinion. It is no use running away from this controversy, and one of the objectives of this book is to bring it into the open. I

mention this now in order to explain what may otherwise seem to be a rather long digression in chapter 1, but which in my view is essential if my arguments are to be seen in their proper context within this wider debate.

A second source which has some bearing on the background to the Danz Lectures, and therefore to this book, was a lecture which I gave on this subject in a series organized by Professor John Wilton-Ely on "Landscape in Art" at the University of Hull in 1984. The scope afforded by a one-hour lecture was insufficient to allow more than a superficial treatment of the subject, so, when I received an invitation from the University of Washington to deliver three lectures, I welcomed this larger canvas as providing what I needed to treat the theme more fully, in particular to establish the distinction between two kinds of symbolism which are equally important in landscape but operate in quite different ways.

The first chapter, then, is concerned with setting the argument in the wider philosophical context; the second explores its further implications for the phenomenon of environmental perception and demonstrates some of the simpler ways in which it may be relevant to architecture, while the third points the way toward understanding its relevance to landscape as encountered in other branches of the arts.

# ACKNOWLEDGMENTS

I SHOULD LIKE here to acknowledge help and advice of various kinds from many people among whom I would specially mention Professor John Wilton-Ely, Professor Michael Thorpe, Dr. Jane Gear, Mr. Brian Fisher, Mr. Keith Scurr, my wife, and the many inhabitants of Seattle, on and off the campus of the University of Washington, whose kindness and hospitality made our visit there in February and March 1988 such a memorable and pleasant one.

The acknowledgment of permissions to reproduce pictures, etc., is made in the relevant captions, and certain other acknowledgments will be found in the footnotes.

I wish also to record my appreciation of the generous gesture of the late Jessie and John Danz in making provisions at the University of Washington for the program of lectures which bears their names, and to express my pleasure at having members of the family attend my lectures and my thanks to the Regents for extending to me an invitation to deliver them.

# THE SYMBOLISM
## OF HABITAT

# 1 SYMBOL, HABITAT *and the* AESTHETIC MYTH

I SHOULD LIKE you to imagine yourselves just over a hundred years ago standing on the Champs de Mars in Paris, France, examining a curious structure. It looks something like the base of a tower, but instead of rising vertically from the ground, it strikes off at such an angle that, if it were to rise much higher, it would surely fall over. Only when you discover three similar structures do you realize that none of them is intended to reach the planned elevation of 984 feet above the ground. Their immediate objective is collectively to support a platform from which a more conventional vertical tower is eventually destined to rise above the city.

The task before us resembles this in that I shall be opening up the ground at a number of points which lie within what we have come to think of as different academic subject areas and which may at first sight seem to have little to do with each other. Our immediate objective must be to reach the equivalent of that basal platform of the Eiffel Tower, so that, before we embark on chapter 2, these initial supports will already have come together, and arguments which at this stage may appear to be somewhat lopsided will already begin to be seen in a wider context. I must therefore exhort you to show patience if the relevance of some parts of my discourse to the title of this book may not be immediately clear to you.

Let us then move straight to our first base where our task will be to look at these words "symbol" and "symbolism." According to the *Oxford English Dictionary* a symbol is "something that stands for, represents, or

denotes something else ... especially a material object representing or taken to represent something immaterial or abstract, as a being, idea, quality or condition."

The use of symbols in the arts is so familiar and so widespread that I scarcely need to furnish examples. In religious paintings, for example, all the saints have their own signs by which they can be recognized. Symbolic dress can be used to identify the ranks of individuals within their respective hierarchies. The Holy Spirit is represented by a dove; abstract qualities by material objects, such as purity by the lily which also doubles for the Virgin Mary. You can think of your own examples and I shall not spend more time on this now beyond looking at one painting.

Figure 1 shows a mural by James Barry, entitled *A Grecian Harvest-Home, or Thanksgiving to Ceres, Bacchus, &c.* It is one of six paintings on the walls of the Great Room of the Royal Society of Arts in London. The series, executed by Barry between 1777 and 1783, of which this is the second picture, was intended to portray Man in the successive gradations of culture, from savagery to final beatitude or misery, depending on how effectively he had utilized the opportunities for advancement provided by nature.

The particular reason why I have chosen this painting is because we have Barry's own written explanation of the symbolism and are therefore relieved of the necessity of relying on our own individual interpretations of it. This is what he says:

> In the foreground are young men and women, dancing round a double terminal figure of Sylvanus and Pan; just behind them are two oxen with a load of corn, and a threshing-floor. On one side [R] is just coming in the father of the feast and his aged wife; in the other corner [L] is a basket of melons, carrots and cabbage, with rakes and a plough, and a group of inferior rustics drinking. In the top of the picture [L], Ceres, Bacchus, Pan, &c. are looking down with benignity and satisfaction on the innocent festivity of their happy votaries; behind them is a limb of the zodiac, with the signs of Leo, Virgo and Libra, which mark this season of the year.
>
> In the distance is a farm-house, binding corn, bees, &c., male and female employments, courtship, marriage, and a number of little children every where. In short I have endeavoured to introduce whatever could best point out a state of happiness, simplicity and fecundity. (Allan n.d.: 3–4)

Not only does Barry draw on the symbolism of a long established mythological system with its deities, signs of the zodiac, etc., whose symbolic meanings would be readily understood by his contemporaries: he is

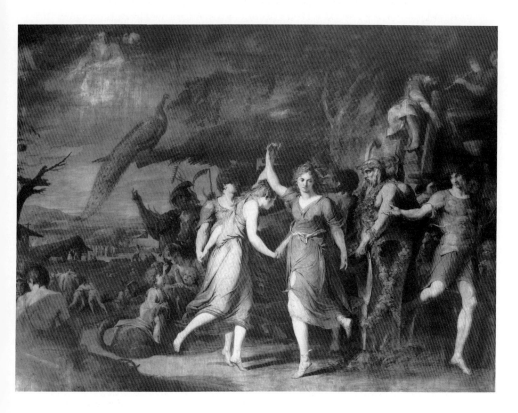

FIGURE 1. *A Grecian Harvest-Home, or Thanksgiving to Ceres, Bacchus, &c.* by James Barry (1741–1806). Reproduced by permission of the Curator-Historian of the Royal Society of Arts, London. For a description see the text.

also making a new symbolic statement about the aims and objectives of the commissioning body whose full title was, and is, The Royal Society for the Encouragement of Arts, Manufacture and Commerce.

The whole pageant is portrayed before a backdrop of landscape about which he says nothing. Can we simply dismiss this as wallpaper arbitrarily devised to conform with what had become the accepted fashion? Does the symbolism stop with the figures and the various activities in which they are engaged, or should we be looking also for some symbolic significance in the background? Why is the rustic building surmounted by a canopy of foliage? Why does the ground fall gently away to a distant horizon? Is there any significance in the shape of that horizon? What about that patch of bright sky immediately above it? Is there some symbolic rationale which applies to the landscape as well as to the figures contained within it, and, if so, where are we to look for that? This is the sort of question which forms the subject of this book.

We must begin our pursuit of it by moving to the second base of our metaphorical Eiffel Tower, to a different discipline, a different terminology and a different set of concepts.

When the ecologist Douglass Morse studied the black-throated green warbler in the northeastern United States, he found that more pairs chose territories in the red spruce forest than in the white spruce forest even though the food density in the white spruce forest was two to three times greater (Morse 1980: 93). The attraction of the red spruce trees was apparently stronger than that of the food supply. The birds could not have known cognitively that, by the time their eggs had hatched and their young required feeding, the food density in the red spruce forest would be as high as that in the white. Something attracted them to what seemed to be the wrong place but eventually turned out to be the right one.

There are many examples of experiments which have demonstrated comparable phenomena among various species of animal. The creatures are powerfully attracted to some object, called "the proximate factor," which in itself has no particular advantage to offer and may even, as in the case of the warblers, appear to be perversely misleading, but which can eventually be seen to point to something else, called "the ultimate factor," which is of crucial importance, like a food supply.

Biologists may not apply the word "symbol" to this phenomenon, preferring the word "sign" or perhaps "sign-symbol," because the word

"symbol" itself has already been preempted in the scientific vocabulary to refer to marks, ciphers, signs and figures which communicate specific ideas, like the difference between the male and female sexes, positive and negative values, mathematical functions, ratios, and so on. But it is clear that the phenomenon itself fits quite precisely the *Oxford English Dictionary* definition of a symbol as "something that stands for, represents or denotes something else."

Such phenomena as orientation and site selection can function efficiently only if animals can recognize not only the objects they see, the sounds they hear, the textures they touch, the odors they smell, and so on, but also their ulterior significance. When I say "recognize," I am not necessarily implying an interpretation involving what we should call "powers of reasoning," although one may note in passing that many ethologists now believe that *Homo sapiens*'s monopoly of reasoning powers is not as absolute as it was at one time fashionable to assume. What I am saying is that, irrespective of the mechanism by which this is achieved, the perception of environmental symbols of this kind is commonly followed by certain kinds of behavioral adjustment which can frequently be seen to have some survival value.

There are many kinds of survival behavior in which some kind of symbolism plays a central role, ranging from courtship display to scent-marking or performances of posturing whereby territorial disputes are settled by methods biologically less counterproductive than mortal combat. But the symbolism which concerns us most closely in the present context is that which regulates the association between an individual organism and its natural habitat. At its most general level, natural selection favors mechanisms which induce the individual members of a species to frequent those types of environment which best suit their life-styles. Whatever we call such mechanisms, they must be capable of establishing an attractive bond between creature and place. At a more particular level, each individual or mating pair of individuals of most species will also be motivated to select a special place, conveniently accessible to the food supply, which can be adapted, with varying degrees of modification, for the purpose of raising a family. Thus the twin concepts of foraging ground and nesting place are intimately related in the process of reproduction, and their initial selection clearly demonstrates the existence of some kind of preference system which must be at least partially innate.

All these kinds of behavior, so essential to the survival of individuals and their reproductive success, are supported by a web of symbolism which resembles the symbolism we encountered at our "first base" (in Barry's mural, for example) in that it also involves objects communicating ulterior meanings, but differs from it fundamentally in one respect. Since this difference is the basis of most of what follows, it is important to spell it out very clearly at this stage.

If you will cast your mind back to that first group of symbols, the Holy Dove, the lily of purity, the signs of the zodiac, and so on, you will realize that they must all have had their origins in some human act of attribution. We may or may not know the circumstances, but always the association between an object and its ulterior meaning must have been made at some time by some person or persons who had the option of nominating some other object to symbolize that meaning. In the same month in which Americans celebrate Thanksgiving, the English observe the fire-festival of Guy Fawkes. I have from time to time questioned the sense of celebrating a failure to blow up the Government, but I have no problem in recognizing the logic of the symbolism. Effigy-burning bonfires, fireworks, turkeys, and cranberry sauce have all been validated by custom as accepted symbolic reminders of important episodes in the histories of our respective countries.

Cult

Symbolism of this kind we can call "culturally determined symbolism" or "cultural symbolism" for short. It is a humanly contrived symbolism in which ulterior meanings can be recognized by anyone who has learned to make the established associations wherever the symbolic object is encountered.

Nat

The symbolism which I exemplified by reference to Morse's black-throated green warblers and their paradoxical predilection for what would at first sight appear to be the wrong tree species is entirely different in this respect. It was never set up, never arranged by anybody. It is a wholly natural phenomenon, an intrinsic part of the survival behavior of the species. This kind of symbolism, therefore, we can call "naturally determined symbolism" or "natural symbolism" for short.

Now if you study the writings of art critics and art historians who have something to say about symbolism in the history of painting you will find that their concern is overwhelmingly with symbols of the former "cul-

tural" kind. (See, for instance, Daniels and Cosgrove 1988.) A major objective of this book is to enquire whether, by looking for evidence of "natural" symbolism also, we can throw any further light on the interpretation of landscape, not just in painting but in the other arts as well.

As we approach our third base, however, I can guess what some of you are already thinking. This kind of natural symbolism may be all right for black-throated green warblers in twentieth-century Maine, but what can it possibly have to do with the most artistic human minds in the Athens of Euripedes, the Italy of Michelangelo, the England of Turner and Constable, or the America of Frank Lloyd Wright? Well, we don't have to believe all the arguments put forward by Robert Ardrey in America or by Desmond Morris in Britain[1] to acknowledge that some characteristics of animal survival behavior are still to be found in our own species and can help to illuminate our understanding of it, not least in the field of environmental perception.

It is, for instance, an indisputable fact that our attention is naturally attracted by some things more than others, by moving objects, by bright light or colored light, or even more so, by a combination of both. Less obviously, perhaps, we are naturally disposed to notice some shapes and patterns more than others, as are other creatures too. This must have implications for any comparisons we may draw, as we shall later, between the fashions for landscape design in seventeenth- and eighteenth-century Europe, in which regularity versus irregularity was the most important single distinguishing criterion. What those implications are we can argue about fiercely. What we cannot do, and still expect to be taken seriously, is to pronounce them from the outset to be irrelevant. To conclude that *Homo sapiens* has no vestigial signs of behavior patterns shared by other creatures or even by our own prehistoric ancestors is wholly proper if that conclusion arises out of the evidence. To build into our premise the assumption that such a link does not exist, and therefore to ignore it, whether from prejudice, aversion, or simply not taking the trouble to establish from circumstantial evidence a *prima facie* case, is not scientifically acceptable or logically defensible.

This point of view, however, is far from being universally accepted, and I shall therefore need to take a little time to deal with the legitimacy of drawing some inferences about our own habits of environmental per-

ception and adaptation from those of our predecessors within the total context of an evolutionary interpretation of life. Within this context, those who are most closely related to us, the more advanced primates and particularly those hominids who, having already acquired recognizable human characteristics, were still living in or near "a state of nature," are likely to be more relevant to our understanding of the links which bind us to our environment than those species to which we are more remotely related. But it is my contention that there is no point at which we can say, "Here the slate was wiped clean; the evolutionary process began again and nothing before that point can throw any light on our understanding of our own perception of, and interaction with, our own environment."

In case you think I am exaggerating the strength of the opposition which, if we allowed it to do so, would stop the development of my argument before it has begun, let me give you one example. This is a comment by an English academic on a paper entitled, "An Ecological and Evolutionary Approach to Landscape Aesthetics," delivered at a conference on "Meanings and Values in Landscape" and subsequently published:

> Frankly, I have very little sympathy with this paper. I do not doubt that as part of nature we intuit strong links between its processes and forms and those of our own bodies, and structuralist theory has suggested something of the consistency in the transformation rules that bring these into language and other social and cultural conventions. But such intuitions are so transformed, overlain and mediated by social, cultural and economic as well as personal meanings historically, that to trace the bio-physiological bases of environmental (*not* landscape) response seems largely futile at best, and at worst pandering to the most dangerously ideological interpretation of 'human nature'. (Cosgrove 1986)

FUTILE

Since Denis Cosgrove, who wrote these words, is one of the most scholarly and authoritative, not to say readable authors currently writing on landscape, he is also, not surprisingly, one of the more influential; so when he makes such a powerful statement dismissing as irrelevant (or worse) what he calls "the bio-physiological bases of environmental response," he must not be surprised if he provokes a reaction from those of us who believe that it is precisely because we have grossly neglected this "ecological and evolutionary" approach that our understanding of landscape aesthetics has not progressed further. Indeed the advocacy of a

wider approach would seem to be entirely consistent with what Dr. Cosgrove himself elsewhere urges (Cosgrove 1980, 1984 and the introduction to Daniels and Cosgrove 1988).

"Landscape," he writes, "is a way of seeing that has its own history, but a history that can be understood only as part of a wider history of economy and society" (Cosgrove 1984: 1). Why, then, should the study of that wider history preclude those ancestral societies whose very survival depended more immediately than ours on finding a favorable accommodation with a more hostile environment? And why should anyone who defines landscape as "a way of seeing" be so dismissive of the scientific study of environmental perception in furtherance of our better understanding of how we see?

Part of the answer must lie in Cosgrove's own interpretation of what he calls "the landscape idea," (a term which he does not always clearly distinguish from the term "landscape" itself), as something unique to capitalist societies within Western (essentially European and American) civilization between 1400 and 1900 A.D. (Cosgrove 1984: 1–2). That is to say he is, on his own admission, setting out an interpretation of an extremely limited (however important) segment of the totality of human experience of, and interaction with, landscape in the sense in which it is commonly understood.

*Social Formation and Symbolic Landscape* (Cosgrove 1984) is an admirable case study, but, like all case studies, it is time and space specific. It can illustrate the ways in which the habits of perception ("ways of seeing") of societies can be constrained by various combinations of circumstances of a social, cultural and economic kind, and indeed it would be difficult to read the book without being persuaded that he has made out a cogent case in terms of this particular example. But a particular study which by its own definition excludes Virgil, Chinese painting and the twentieth-century cult of "wilderness," to name but three areas of the study of landscape which have generated their own extensive literatures, can only be said to exemplify, not to constitute, a general theory of landscape. For that we must cast the net much farther afield and embrace not only that "wider history of economy and society," as he himself insists, but indeed any sources, whether in the arts or the sciences, which can throw light on our "ways of seeing." That is what lateral thinking is all about.

While nobody could seriously question that Cosgrove is right in saying that those intuitions to which he refers are "transformed, overlain and mediated by social, cultural and economic as well as personal meanings historically," the question is whether these influences have been able *totally* to eradicate them. If, for example, we take the word "overlain," do we see it like a geological unconformity, in which later deposits have been spread across earlier ones to which they bear no structural relationship, or like an oriental cabinet in which a veneer of lacquer has totally covered the original surface, altering its colour, its texture and its reflective properties but still expressing the configuration of the woodwork underneath? Dr. Cosgrove appears to go for the former view; I go for the latter with, I am sure, the author of the paper he was criticizing in the passage quoted above (Orians 1986) and a large and increasing number of ethologists and environmental psychologists who have addressed the problem. One is never assisted in one's search for anything by the conviction that all traces of it must inevitably have disappeared, so I suppose the task of searching for a link between what Dr. Cosgrove calls "the bio-physiological bases of environmental response" and the artistic expressions of civilized men and women must necessarily fall to those of us who have not closed our minds to the possibility of success.

Perhaps I had better confess at this stage that my arguments will be set in an unashamedly Darwinian framework. For those who are still reluctant to accept it, not having time to argue the general case now, I will content myself with quoting a few lines from the eminent biologist, François Jacob, when he said in an earlier series of Jessie and John Danz Lectures:

> It has today become virtually impossible to account for the tremendous amount of data accumulated during the last few decades without a theory very close to modern Darwinism. The chance that this theory *as a whole* will someday be refuted is now close to zero.
>
> (Jacob 1982: 18–19)

One of the reasons why there has been so much resistance to the idea of evolution by natural selection has always been an aversion to its implications for the dignity of our own species. We fear that the values we attach to great works of art are somehow put at risk by the very notion

that they may proceed out of the same laws of biological behavior which govern the rest of the animal world. We recall those uncomfortable lines of Hamlet when he says:

> What is a man,
> If the chief good and market of his time
> Be but to sleep and feed? A beast, no more.
>
> (4.4.33–35)

However, it is equally pertinent to recollect that there was a time in the lives of all of us when Hamlet's lines were not far wide of the mark. It would be quite irrational to feel that the artistic reputation of the composer of the late quartets was somehow demeaned by the knowledge that half a century earlier Baby Beethoven's immediate ambitions had been pretty well confined to sleeping and feeding. A beast, no more?

The point is that, in invoking the study of other animals, we are looking not for a mirror of our own behavior but rather for clues to our better understanding of how it has come to be as it is. We know that we are different from other creatures, just as we know that the oak is different from the acorn. The whole concept of evolutionary change implies that some characteristics are replaced by others, while some are retained, and in order fully to understand what something has changed into we need also to know what it has changed out of. Just as Edmund Burke in his famous essay was inquiring into "the *origins* of our ideas on the sublime and the beautiful" (Burke 1757), so my concern is with the origins of our responses to landscape as encountered through direct interaction with it and thence through its representation in the arts.

The most important difference between our own machinery of perception and that of other creatures lies in the vastly greater complexity and potential of the human brain. However, we have not simply discarded the old and replaced it with something entirely different. Rather, a vastly more powerful intellectual instrument has been, as it were, grafted on to the old one, or something very like it, which is still there. François Jacob again:

> The old structure, which in lower mammals was in total command, has in man been relegated to the department of emotions, and constitutes what McLean calls "the visceral brain." Perhaps because development is so prolonged and maturity so

delayed in man, this center maintains strong connections with lower automatic cen-
ters and continues to coordinate such fundamental drives as obtaining food, hunting
for a sexual partner, or reacting to an enemy. (Jacob 1982: 36–37)

This is precisely the kind of fundamental survival behavior about
which I shall be having quite a lot to say in these lectures, not least with
reference to the pleasure associated with such behavior. Concerning this
the neurophysiologist, H. J. Campbell, says:

> The only clear and observationally undeniable difference between man and the
> lower animals lies in the organization and use of the brain with respect to the plea-
> sure areas. It is from this that the differences in behaviour, such as they are, arise.
> (Campbell 1973: 71)

The "pleasure areas" are to be found within that "visceral brain." A
little later he says, "the basal neural mechanisms of sensory perception
appear to be the same in man as in the rat" (Campbell 1973: 110). Later
still he says:

> The only way, also, in which we can sensibly account for what has been happen-
> ing in evolution is to believe that the pleasure-displeasure mechanism has been the
> one universal, overriding force behind the increasing complexity of animals. (Camp-
> bell 1973: 229)

Campbell also makes it very clear that this is the same pleasure-
displeasure mechanism which is responsible for building those bonds of
association between individual organisms and their habitats, their nesting
places and their foraging grounds. However widely the *criteria* of selec-
tion may vary from species to species, the *process* of selection is always
preference based. Those creatures enjoy better prospects of survival
which are more powerfully motivated *by attraction* to seek out and re-
main within territory which offers the means of satisfying the require-
ments of their own particular life-styles. If, therefore, there is such a close
affinity between our own neural systems and those of what we presume
to think of as inferior creatures, at least in those areas in which the
pleasure-displeasure mechanism is operative, would it not be wholly il-
logical, without convincing evidence, to dismiss these concepts of habitat,
nesting place and foraging ground as irrelevant to the study of those
emotional links which bind us also to our environments?

In short, has *Homo sapiens* also a natural habitat to which its individual
members find themselves naturally drawn by some force within them, a

force which is as much a characteristic of their species as the possession of two eyes, a mouth, and a nose, or is our species unique in having this one area of behavior exempt from the operation of Campbell's "pleasure-displeasure" mechanism?

Within comparatively recent times several researchers have addressed this problem, particularly Balling and Falk (1982) and Orians (1980, 1986). I have not the time here to develop these arguments in full, so I will simply ask you to note that, in the opinion of most authorities, if there is a type of environment which we as a species can recognize as our natural habitat, it has to be the savannah, that type of plant association which takes a variety of forms in different parts of the world but consists essentially of trees spaced widely enough to permit the growth of grasses between and underneath them. This is now generally agreed by the anthropologists to be the kind of environment in which the first recognizable hominids made their home; and Orians argues that the power of attraction, whatever its *modus operandi,* which drew them towards this favorable kind of landscape, has not been eliminated from our genetic make-up but has survived—in Jungian terminology—as an archetype, whose influence is still to be seen in many ways, not least in the widespread attraction which people feel towards "parkland," an idealized, contrived arrangement of well-spaced trees within a tidily groomed grassland.

If this is so, the phenomenon of landscape preference or landscape taste cannot be explicable solely in terms of social, historical or cultural contexts. It makes much more sense to see these contexts as moulding systems of preference which, in their essential outlines, are already there, having been genetically transmitted from generation to generation.

The phenomenon of pleasure provides the cue for us to move on to the fourth and last of the bases of our imaginary Eiffel Tower. There we find waiting for us a posse of art critics, art historians and aestheticians to whom we have to sell the idea that the arguments we have just been considering may be able to throw some light on the whole question of aesthetic values and where they come from.

We shall find some who, following John Dewey and the American Naturalist School (Appleton 1975: 48–50), have firmly embraced the idea that we must look for the origins of aesthetic values in the laws of the behavioral sciences, including biology, psychology and ethology. But

strong pockets of resistance have persisted. Their forces may not be co-ordinated, and their anxieties may find expression in a variety of ways, but collectively they comprise a kind of aesthetic priesthood which has assumed responsibility for defending what I shall call "the aesthetic myth." In using this terminology I am not intending any offense to those who share these views. To describe something as a "myth" does not nec-essarily imply that it is false; merely that its validity ultimately depends more on faith than on proof, while the term "priesthood" implies a com-mitment to a *corpus* of related ideas analogous to those embodied in a religious creed. The use of both these terms carries the suggestion that the basic assumptions on which they rest cannot be falsified solely by rational argument since the "truth" they are perceived as expressing de-pends ultimately on the convictions of those who subscribe to them.

In the context of landscape aesthetics, the position to which I am refer-ring has been well expressed by Don Meinig of Syracuse University, but I must make it clear that he does not say, neither am I suggesting, that he personally agrees with it. Meinig says:

> Landscape becomes a mystery holding meanings we strive to grasp but cannot reach, and the artist is a kind of gnostic delving into these mysteries in his own private ways but trying to take us with him and to show us what he has found. In this view landscape lies utterly beyond science, holding meanings which link us as individual souls and psyches to an ineffable and infinite world. (Meinig 1979: 46–47)

The gap here is between two separate fields of experience. The prin-ciples by which they operate and the values we find in them are *intrinsi-cally* different and only the artist can bridge the gap. You will notice how close the language comes to portraying a "priesthood" with its private lines of access to a mystical world and its associated sense of missionary obligation.

This is not simply a minor difference of emphasis which we can pass over as of little consequence, because, if it is true, if landscape (and there-fore by implication its representation in the arts) as thus interpreted lies utterly beyond science, it is a waste of time to try and establish any mean-ingful links between them. I shall therefore make a digression at this point to direct your attention to some examples which will collectively demonstrate the nature and the weight of the arguments which still widely prevail and into which I shall be attempting to inject ideas which

are alien and often disturbing to those who hold what many consider to be the orthodox position.

As my first example let me take a passage from the art critic and historian, Clive Bell:

> Art transports us from the world of man's activity to a world of aesthetic exaltation. For a moment we are shut off from human interests, our anticipations and memories are arrested; we are lifted above the stream of life.... The rapt philosopher, and he who contemplates a work of art, inhabit a world with an intense and peculiar significance of its own: that significance is unrelated to the significance of life. In this world the emotions of life find no place. It is a world with emotions of its own. (Bell 1914: 25–27)

I think you will understand that, when the holy-of-holies is defended by this kind of weaponry we may have problems in penetrating it with the mere language of the biological sciences, a language which is pronounced irrelevant by the aesthetic priesthood from the start. Indeed the literature contains many examples of this kind of rebuff, the imposition of what we might call an "axiomatic closure" at the outset. It comes in different forms of which the following is one. The subject under discussion is the difference between "aesthetic" and "non-aesthetic" and one might expect the argument to begin with a definition. But no!

> I make this broad distinction [between aesthetic and non-aesthetic] by means of *examples* of judgments, qualities and expressions. There is, it seems to me, no need to defend the distinction. Once examples have been given to illustrate it, I believe almost anyone could continue to place further examples—barring of course the expected debatable, ambiguous or borderline cases—in one category or the other. To deny such a distinction is to be precluded from discussing most questions of aesthetics at all. (Sibley 1965: 135)

I am sure that even the nonscientific readers of this book will understand the despair experienced by, say, a biologist confronted with this kind of impasse, since it appears to preclude by axiom the possibility that there may in fact be no definable difference between aesthetic and non-aesthetic and that the origin of all pleasure is most plausibly to be explained in that same principle which is the driving force of all survival behavior.

Another writer who finishes up threatening us that we will not be allowed to play the game if we don't like the rules is John Hospers.

The simplest subjectivist theory, which has a superficial attractiveness but is quite certainly mistaken, is the view that when somebody says "*x* has aesthetic value," he is saying only, "I aesthetically enjoy *x*" or "I have an aesthetic experience in response to *x*." . . . Most aestheticians, indeed, would say that such judgments are statements of personal liking or preference and not aesthetic judgments at all. "I like it" is quite different from "I think it is (aesthetically) good". . . . There are many other objections to the subjectivist view, the principal one perhaps being that it makes disagreement on aesthetic matters impossible. (Hospers, 1967: 54)

Since the argument which Hospers so disdainfully dismisses as "quite certainly mistaken" is almost exactly that which I am now putting forward, I can give an assurance that disagreement is far from impossible.

If we turn from the aestheticians to the art critics we may find ourselves received without any dogmatic hostility but nevertheless confronted by problems of a different kind. One such can be illustrated by the following quotation from Barbara Novak writing about the exhibition of "luminist" paintings held at the National Gallery of Art in Washington, D.C. in 1980 under the title *American Light:*

Luminist light tends to be cool, not hot, hard not soft, palpable rather than fluid, planar rather than atmospherically diffuse. Luminist light radiates, gleams, and suffuses on a different frequency than atmospheric light. With atmospheric light, which is essentially painterly and optical, air circulates between particles of strokes. Air cannot circulate between the particles of matter that comprise luminist light. . . . Luminist time is absolute. It is Platonic and Newtonian. It is "shaped" time, controlled by strict measure. (Novak 1980: 25)

If we were to make the mistake of taking Ms. Novak literally we should be forced to conclude that this is pure gibberish. It doesn't require a physicist to tell us that the properties which she attributes to light and to time are properties which they cannot possibly possess. In fact, of course, we do not take her literally; we know very well that we are not supposed to, but it does illustrate the sort of difficulty that may arise if we try to introduce ideas couched in the prosaic language of science into an area of discussion where the local dialect is the poetic language of metaphor.

I think it was this difficulty of marrying the different traditions of art and science which confronted Iredell Jenkins in 1958 when he wrote a book called *Art and the Human Enterprise,* in which he explicitly set out to apply a Darwinian interpretation to aesthetic experience.

> With respect to the fundamental issue, . . . I shall accept as my point of departure the general theory of evolution. . . . [Scientists] assume that man is an evolutionary product and that his structure, his capacities, and his modes of action all have their basis in the process of adjustment. . . . All that is here proposed is the systematic extension of these assumptions to those higher and distinctively human activities to which they have hitherto been applied, if at all, in only a random and hesitant manner. . . . I am arguing that even the most refined and complex of man's creations have their basis in the process of adaptation, and find their function as instruments of life. (Jenkins 1958: 5–9)

I have no quarrel at all with this: indeed it is almost exactly the line I am taking myself, but unfortunately Jenkins soon begins to tremble at the specter, not of Darwin, but, one suspects, of B. F. Skinner, and he begins to introduce a series of qualifications, concluding with this extraordinary statement:

> Whenever I speak of "the environment," of "the conditions and instruments of life," of "the things" we encounter and deal with in "the world," of "evolution" and "the adaptive situation," I am using these terms in a purposely ambiguous manner, so as to leave their reference undetermined and imprecise. (Jenkins 1958: 10)

The consequence of this ambiguity and imprecision is that Jenkins is forced to abandon anything like a literal interpretation of his declared intention to pursue a Darwinian approach before the end of his first chapter, and we should not be surprised that he scarcely mentions Darwin again.

Perhaps I can best bring home to you the nature of my problem by quoting a short passage from the entry under "Aesthetics" in the 1974 edition of *Encyclopedia Britannica*:

> It is as if the instigating problem for aesthetics were to account for the values attributed to these arts—to poetry, drama, dance, music, painting, sculpture, architecture. Having explained the values of the arts, a theory may then expand these values as widely as they may go to natural objects, to acts of living, eating and drinking, playing and loving, and even to dreaming. But it is the explanation that can be given for deeply prized works of art that stabilizes an aesthetic theory.

Note that this system of values starts with the arts and may then be expanded to "acts of living," etc. Those of us who believe that the truth is precisely the opposite—that the values attributed to the arts have developed *out of* the rules for surviving in a potentially hostile environment—have first to persuade the court to give us a hearing. Some of the sciences

have already been admitted to put their case. The mathematical sciences, for example, are regarded as highly respectable. The idea that beauty resides in particular geometrical shapes, the perfect sphere, for instance, or the perfect circle goes back to the ancient world, as does the theory that aesthetic properties are attached to certain kinds of geometrical relationship, such as are to be found in symmetry or in certain ratios, like the golden mean, golden section or golden rectangle, which has long been invoked to explain the aesthetic properties of the fenestration of classical buildings.

The pointillist techniques of the neo-impressionists were deliberately contrived out of recent discoveries in chemistry and the physics of light, while the physics of sound tells us that harmony and dissonance in music are all a matter of vibration-frequency ratios. Even among the behavioral sciences some have already obtained a firm foothold. Psychology is regarded as a serious applicant, and the psychology of art already has a place in the recognized classifications of the literature, but if biology has been seen to have anything to do with aesthetics and the arts, its emphasis has been strongly morphological rather than functional. The study of anatomy was long regarded as a proper part of the training of an artist who aspired to paint the human figure; but the study of behavior, in human beings, never mind animals, has yet to pass the preliminary examination of the "Aesthetic Priesthood," and the "Board of Examiners" contains some diehards who would see it admitted over their dead bodies.

I must ask you to note that I have no wish to exclude any established explanations of aesthetic values except those which themselves pursue policies of exclusion. I am merely pleading that other approaches also be legitimized and taken seriously, at least until they have been *shown,* and not merely assumed, to be false, and in particular that we should recognize a central role in aesthetics for the study of environmental perception. To quote François Jacob once more:

> Living beings can survive, grow, and multiply only through a constant flow of matter, energy and information. It is therefore an absolute necessity for an organism to perceive its environment or, at least, those aspects of its environment that are related to its life requirements. . . . Obviously, the increase in performance that accompanies evolution requires a refinement of perception, an enrichment of the information received concerning the environment. . . . In birds and even more so in mammals, the enormous amount of information coming from the environment is sorted out by

the brain, which produces a simplified and useful representation of the external world. The brain functions, not by recording an exact image of the world taken as a metaphysical truth, but by creating its own picture. (Jacob 1982: 55)

I hope that you can by now begin to see the relevance of this for an interpretation of landscape in the arts. For a concise working definition of "landscape" I would suggest "the environment visually perceived." The image of that environment, which to each of us individually represents reality, is already, according to Professor Jacob, a creative work of art. At the same time he makes it clear that the process of perception, which is the agency that creates this work of art, is also the master activity on which all survival behavior depends, and that there can be no environmental adaptation without environmental perception.

The Greek verb meaning "to perceive" is *aisthanomai,* from the adjectival form of which is derived our word "aesthetic." "Aesthetic pleasure" means literally "pleasure associated with or deriving from perception." The idea of beauty is a secondary association which has been loaded on to it within comparatively recent times.[2]

Philosophers themselves are now well aware of the dangers arising from this association, not least because it may be taken to imply the existence of beauty as an inalienable property of objects which we call "beautiful," comparable with other properties like smoothness or roundness or weight. The saying that "beauty is in the eye of the beholder" is surprisingly modern. According to *The Oxford Dictionary of Quotations* it was first used by Margaret Countess of Hungerford in a novel (*Molly Bawn* ) of 1878, but the idea is much older. The word "beauty" in fact is so unsatisfactory that it is not now in general use among philosophers. Wladyslaw Tatarkiewicz delivered the *coup-de-grâce* in a paper entitled "The Great Theory of Beauty and Its Decline." That was in 1972, the same year in which Nicholas Humphrey in Cambridge, in a paper called "The Illusion of Beauty," staked a claim for the rights of zoology to have something to say on the matter.

It has taken us a long time to reach the basal platform of our Eiffel Tower from which we can now begin to erect our superstructure. I have had little time, even so, to support my arguments with more than a smattering of evidence. For that you will have to turn to the already large and rapidly increasing volume of published work. But it is not my purpose to present you with a cast-iron case such as an advocate might seek to place

before a judge or jury. Rather it is my more modest intention to inject certain ideas into an ongoing argument and to leave it to you to place on them whatever interpretation or whatever degree of credence you think they may support.

Let me then briefly summarize the ground we have covered so far. Our habits of environmental perception, while they are invariably modified and shaped by cultural, social, historical and personal experiences, are not created out of nothing by these influences; rather they are the derivatives of mechanisms of survival behavior which were already there, elements of our innate make-up. Aesthetic pleasure is the pleasure of *perception*. Environmental perception is the key to environmental adaptation which in turn is the basis of the survival of individual organisms and a central theme in the Darwinian theory of evolution by natural selection, while pleasure emerges both as the driving force of the whole biological system and as the criterion of excellence in a hedonistic aesthetics.

The artist, therefore, who, in whatever medium, seeks to induce pleasure both in himself and in those who perceive his work, can never entirely escape from the operation of those basic scientific laws which govern the phenomenon of perception. And if, in their analyses of a landscape painting, art critics confine their interest to what I have called "cultural symbolism," they will be in danger of failing to make contact with that underlying web of natural symbolism which links the objects we perceive in the landscape with their ulterior messages of encouragement or warning.

The task of looking for and interpreting such "symbols of opportunity," as I shall call them, will be our principal objective in the next chapter.

# 2

# THE ANALYSIS OF LANDSCAPE *and the* SYMBOLISM OF OPPORTUNITY

BEFORE WE CAN begin looking for examples of what I have called "natural symbolism" in landscapes or artistic representations of landscapes we shall need to clear up one or two procedural problems, and the first of these must be to satisfy ourselves that we have a language adequate to cope with the task in hand.[3] There are very few descriptive words or phrases which we can apply to a landscape as a whole, one single entity. We can talk about a desert landscape, a winter landscape, an urban landscape, a mountainous landscape, a "Great Plains" landscape, and so on, but very soon we are reduced to making observations about its component parts, and the vocabulary of landscape description has evolved to give expression to this. Of all the parts of speech employed in this descriptive terminology the noun is by far the most important. We talk of hills and valleys, rivers and lakes, forests and farms, towns and villages. They may, of course, be adjectivally qualified—a tall hill, a narrow valley—and we may use adjectives to introduce a measure of sentiment, emotion or value judgment, such as a cosy cottage or an ugly billboard, but unquestionably in landscape description the noun is king.

This is especially so in those attempts, now very numerous, which have been made to assess the aesthetic value of landscapes in quantitative terms with a view to representing such values on maps. It is comparatively easy, for example, to assess the proportion of an area—a square mile, perhaps, or a square kilometer—covered by forest or by water, or by arable land. Many questions can be reduced to the binary form of a yes/no answer. Is water present? Are buildings visible? Yes or no? Place a tick in the appropriate box.

This approach has at least two advantages. It facilitates the task of measurement, permitting the use of aerial photographs which rapidly cover large areas, and it presents the information in a form highly digestible for the computer. A major disadvantage is that it involves assumptions about the correlation between aesthetic values and the presence or absence of particular categories of environmental object, and that is precisely the area where we are on the weakest ground. In spite of the refinement of techniques which has undoubtedly occurred, there is still a widespread scepticism among the public as to whether the maps prepared by these methods really indicate what they purport to represent, namely the differentiation of areas according to their aesthetic qualities or values.

This is the problem I now wish to address. If a symbol is an object which "stands for, represents or denotes something else," ought we not to be paying less attention to the objects which comprise a landscape and more attention to that "something else"? The question is where to find it, and my suggestion is that we should look first to that system of natural symbolism which is central to the process by which creatures are enabled to establish favorable relationships with their natural habitats.

If environmental perception is an essential prelude to environmental adaptation it is of the utmost importance that the perceiving organism shall be able to act on the signals given by these symbolic objects. It must be interested in both these questions, not only What is it? but also What's in it for me? To the phenomenon implied by this second question the environmental psychologists have given the name *affordance*. (Gibson 1979)

Now I think you will already have understood that this symbolic conversion from the morphology of the object to the behavioral opportunity to which it points implies also a conversion from the noun to the verb. Now that I have perceived and recognized the object, what does it mean I should do? Consequently it raises serious doubts as to whether a morphological system of landscape description based on nouns is adequate to handle a functional system of analysis based on the differential opportunities for behavioral response. When we look at trees set in open ground we are now thinking of them not so much as objects with recognizable characteristics by which they can be allotted their proper place within a taxonomic system of classification, but rather as objects suggesting oppor-

tunities for doing simple things like seeing further or hiding better or climbing to safety. We see rivers not simply as morphological components of the landscape but rather in terms of their several functions. We may see them as providers of water, a basic necessity for the maintenance of life, or we may see them as channels along which we can move if we have the means to do so, or as obstacles to impede our passage if we have not.

This last case introduces us to an important property of this kind of symbolism, namely *ambivalence*. Many environmental objects may communicate conflicting signals. What seems to be a place in which we can hide safely may already contain something nasty which has got there first. Jean Paul Richter recounts how Leonardo da Vinci described just such an ambivalent experience:[4]

> I came to the entrance of a great cavern, in front of which I stood some time. . . . Bending my back into an arch I rested my tired hand on my knees and held my right hand over my downcast and contracted eyebrows: often bending first one way and then the other, to see whether I could discover anything inside, and this being forbidden by the darkness within, and having remained there some time, two contrary emotions arose in me, fear and desire—fear of the threatening dark cavern, desire to see whether there were any marvellous thing within it. (Richter 1970: 2: 324)

The literature of ethology, the study of animal behavior, is full of passages descriptive of such exploratory activity. Symbolism of this kind is rarely like a pedestrian-crossing sign which says either "Walk" or "Don't Walk" but never both at the same time. It is more like a notice which warns us to drive with care, not making our decisions for us but spelling out the message that potential danger lies ahead and that we must be prepared to make a decision on how best to adjust our behavior to what we shall find when we encounter it.

In *The Experience of Landscape* (Appleton 1975), I made a speculative attempt to suggest how we might begin to construct a classification system which would enable us to break down landscapes for descriptive purposes into functional rather than morphological categories. I identified two elementary concepts to which I attached the names *prospect* and *refuge* respectively. A third category, which I called *hazard,* encompassed all those sources of danger which it might be necessary to avoid by whatever means. From these elementary beginnings I attempted to build a

more elaborate structure with an associated vocabulary more appropriate for the purpose of aesthetic interpretation rather than mere morphological description.[5]

You have probably noticed that this new terminology is still based on the use of nouns, which can still be used, like hills and valleys, as concrete nouns—a prospect, a refuge, a hazard. But they can also be used as abstract nouns communicating the idea of concepts, and as such they are more closely related to functions which in turn can be expressed by appropriate verbs, even if we most commonly encounter them in substantive form, in gerunds, if you like. So prospect is to do with perceiving, with obtaining information, particularly visual information; refuge with hiding, sheltering or seeking protection. The concept of hazard implies the proximity of something which threatens, menaces or disturbs our equilibrium; at another level, if we think of it in terms of our behavioral response, the symbolism of hazard prompts evasive action, like hiding, escaping or eliminating the source of danger.

By analysing landscapes into categories based on concepts of this kind, we can begin to break into an alternative system which turns out to be more closely concerned with natural than with cultural symbolism. It may indeed find expression through cultural symbols, through buildings, for example, expressive of their own socio-historical context, but to say that is very different from saying that it has been so overlain by culture as to be no longer relevant.

So, if we turn back to Barry's mural (fig. 1) which we found to be so rich in overt cultural symbolism, we find that it is also full of natural symbolism. If we can't find any traces of it, it is either because we haven't looked for them, possibly having been deterred by the assurances of the sceptics that no such traces can exist, or because we are not able to recognize them when we see them.

The first thing I would notice is that Barry has divided his painting into two roughly equal parts. The left is heavily dominated by the symbolism of prospect with its long views into the distance. On the right-hand side the distant view is blocked by a low rustic building strongly symbolic of refuge and made even more so by hiding under a canopy of arboreal foliage. It also serves to make the foreground on the right into a secluded stage on which the dancing figures are fully illuminated in a protected arena. To the left a band of cloud shadow separates the fore-

ground from the distance—the idealised nesting place from the idealised foraging ground. The gentle declivity away from the vantage point is optically necessary to open up the view, but it also arouses that sense of strategic advantage which is always implied when our immediate defensible space is higher than its surroundings. Notice that the level horizon rises on the left into a sharply delineated hill and that the heavy dark cloud, in addition to providing a convenient vantage point for the accommodation of the deities, serves also to accentuate by contrast the brightness of the lower part of the sky immediately above the horizon, thereby strengthening its prospect value and its power of attracting the eye.

If our analysis were confined to this one painting, you might well think that such an interpretation was a kind of special pleading, too arbitrary and tenuous to be worth taking seriously. But the features just picked out, along with a number of others, are to be found constantly recurring in landscape painting.

For example, by dividing a painting into prospect- and refuge-dominant halves in this way (fig. 2), an artist can break down for us the totality of the perceptual experience, so that we can within the same picture savor the sensations of prospect and refuge separately but in a unified composition—refuge to the left, prospect to the right, or vice versa, as the case may be. This is a very common device in landscape painting.

I have elsewhere drawn attention to the significance of this in portraiture. Where, as is often the case, the landscape background is divided in this way (fig. 3), if the subject is inclined to one side or the other, it is usually to the prospect side, which would be the natural attitude in terms of strategic opportunity. And when Thomas Hudson portrays the composer George Frederick Handel the wrong way round (fig. 4), it merely serves to emphasize the message that the poor old man is by now so nearly blind that he can only see the score of his oratorio, *Messiah,* if the light comes from behind him. Even so, every time I visit the National Portrait Gallery in London I feel like saying, "Excuse me, Mr Handel, sir, but wouldn't you like me to turn your chair the other way round?"

When environmental perception becomes organized into the sequential phases of a single purposeful operation, we can call it *exploration. Homo sapiens,* like all other creatures, is an exploring organism, driven to discover where things are and what, if anything, is their symbolic mes-

sage. The long-term benefit is an improved chance of survival. The immediate inducement is curiosity, and its reward, in the terminology of H. J. Campbell (1973), is "the stimulation of the pleasure areas" which to you and me means simply the attainment of pleasure.

Let us then investigate more closely some of the objects which appear to convey symbolic messages to the observer and to obtain at least a cursory view of how they are used in landscape art. We could begin with the horizon, which in Barry's painting (fig. 1) assumes two forms. Part of it is flat and level. (Where, indeed does the word "horizontal" come from?) The other part rises in the outline of a hill. Whatever the shape of a horizon, it can be defined as "the further limit of a surface visible from a particular vantage point." It has no absolute existence independent of that vantage point. It separates that portion of the field of vision which can be perceived by the eye from that which can be reached only by the imagination (fig. 5). There can, of course, be more than one horizon, but, unless otherwise specified, the word is usually taken to refer to the most distant of them.

The capacity to speculate on what lies behind a horizon varies greatly from one person to another. In a vivid imagination what lies beyond can become so real that the horizon is perceived as an artificial internal boundary in a continuous surface, which, of course, is precisely what it is. Let me quote a few lines from that very sensitive observer, Siegfried Sassoon, describing the view from his childhood home in Kent, England:

> Looked at from our lawn, the Weald was, in my opinion, as good a view as anyone could wish to live with. You could run your eyes along more than twenty miles of low-hilled horizon never more than twelve miles away. The farthest distance had the advantage of being near enough for its details to be, as it were, within recognizable reach. There was, for instance, a small party of pine trees on the skyline towards Maidstone which seemed to be keeping watch on the world beyond—a landmark on the limit of my experience they always seemed, those sentinel pines. I often looked at them through my toy telescope. The idea of the places beyond those hills was physical sensation which I experienced with ignorant relish while I gazed "into the blue distance." That Rochester, Chatham and Strood could possibly be unattractive towns was a thought which had never occurred to me. The foreground was an easy-going prospect of meadows, orchards and hop-gardens, supervised by the companionable cowls of hop-kilns (or oast-houses, if you prefer it). The Medway was there winding lazily past Wateringbury on its way to Sheerness, where Uncle Don went when the destroyers from the Works were being tried: he always called

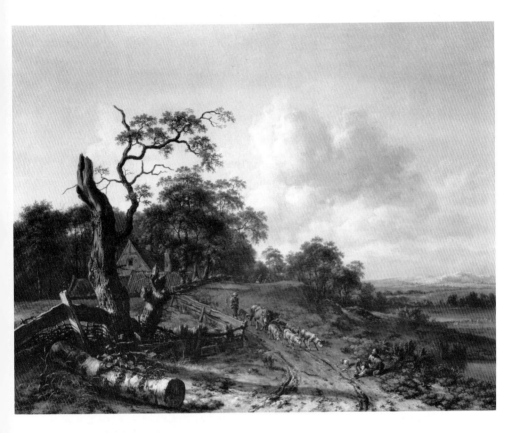

FIGURE 2. *A Landscape with a Dead Tree and a Peasant Driving Oxen and Sheep along a Road* by Jan Wijnants (1631/32—84). A typical "half-and-half" picture with the symbolism of refuge concentrated on the left and that of prospect on the right. The building on the left is a good example of the "cottage-in-the-wood," a very common refuge symbol in paintings of all periods. Reproduced by courtesy of the Trustees of the National Gallery, London.

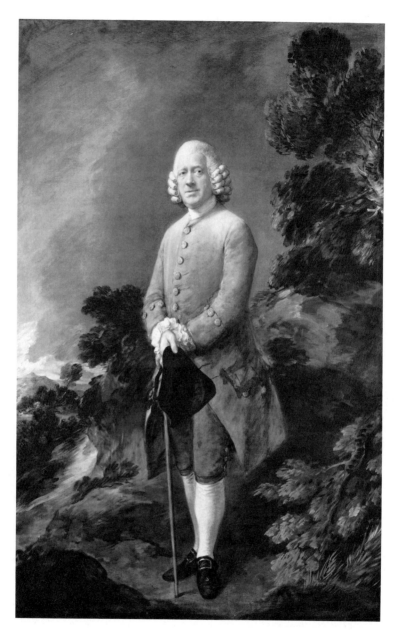

FIGURE 3. *Dr. Ralph Schomberg* by Thomas Gainsborough (1727–88). The "half-and-half" division (see figure 2) is very common in portraits with a landscape background. Where the figure is inclined to one side or the other it is nearly always towards the "prospect" side. Reproduced by courtesy of the Trustees of the National Gallery, London.

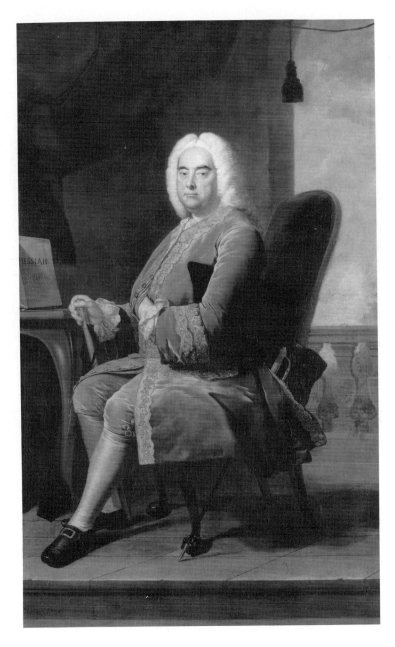

FIGURE 4. *George Frederick Handel* by Thomas Hudson (1701–79). Reproduced by courtesy of the Trustees of the National Portrait Gallery, London.

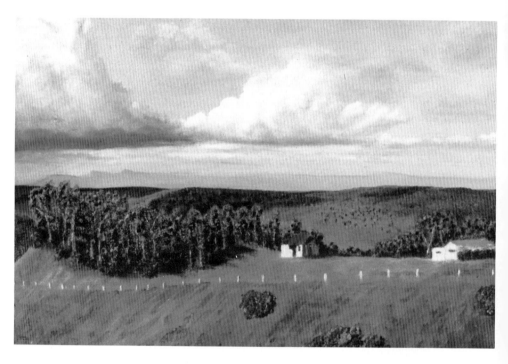

FIGURE 5. *The Richmond Range from the Bruxner Highway: View to the North from Near Mallanganee, New South Wales.* Painting in oils by Jay Appleton. Successive horizons terminate three visible surfaces at increasing distances from the observer.

the Medway the Mudway, and thought the Thames a much better river. Sometimes in quiet weather, I could just hear from beyond the horizon, a faint muffled thud, which meant, I was told, that they were testing a big naval gun at Sheerness. (Sassoon [1938] 1980: 124–5)

Let us just have a look at some of the ideas which come out of this passage. You will notice how the description of the visible components of the landscape is solidly based on concrete nouns—meadows, orchards, hop-gardens, cowls of oast-houses, the river and the pine trees. These last appear as a focal symbol representing the idea of places in the unseen landscape beyond. But the language of the noun is supported by the language of the verb; the morphology conjures up the image of the function. With a poetic touch of animism the pines themselves are seen as "sentinels," "keeping watch" on the world beyond, a world in which events and processes are as important as places and objects. The river winds lazily down to join the Thames. Uncle Don, co-owner of the Thornycroft Engineering Company, goes off to work at the Chiswick shipyards, and the evidence of the eye is joined by that of the ear when the big guns are fired. The horizon and the pine trees which surmount it are the gateway into the faraway, the symbols of everything beyond, real or imagined.

In another passage he links this spatial boundary between the visible and the unseen environment with the temporal boundary between what is here and now, the present, and what is to be anticipated, the future:

Beyond the garden and the wood below it, and across the valley, were those distant hills: and the future seemed to lie beyond them. It was from there that visitors came to see us, out of their far off lives which were so unknown and interesting, like things that happened in books. (Sassoon [1938] 1980: 180)

I once attempted to express something like this in a little poem called *Here and There*. (Appleton 1978: 24)

Cherish the brutal bars rising,
Halt at the creaking door closing,
    Smother the longing to break and be gone;
Here shall the rambling years keep you,
Here shall the spring-green sap shape you,
    Here is a garden and there is the sun.

Often the earthbound self reaches
Into the wild unseen spaces

Looking for fire in a faraway dome;
What are the winking stars hiding?
Where is the windsped smoke leading?
Why is reality never at home?

Only the bright-eyed child, seeking,
Only the restless bird, aching,
Lend to creation a semblance of care:
When we resolve this strange fever,
Find the refining dream over,
Where will tranquility journey from there?

This theme of being in one place and projecting the imagination into another, as yet unattainable—we can call it the "here-and-there" theme, if you like—is a constant feature of romantic art and I shall come back to it again later, but just note in passing that the capacity to anticipate what we have not yet attained is a fundamental part of successful survival behavior. A creature which can predict what is going to happen in a situation not yet encountered from its observations of the events which precede that situation, a creature which has not only a capacity for, but a compulsive interest in inferring from the perceived the as-yet-unperceived, obviously has a better chance of success than one which, being uninterested in such imaginative speculation, allows itself to be taken unawares. The speculative process itself becomes a source of fascination, the imagined world which it creates a source of pleasure, and there is nothing in the landscape which so powerfully evokes that fascination and that pleasure as the horizon. It has been said that the most evocative line in the English language comes from a nursery rhyme:

Over the hills and far away!

Like any other feature of the landscape, however, the horizon can express its symbolic meaning in various ways and with various degrees of intensity. This is demontrated in figures 6–14, *Horizons*, a series of drawings of the same imaginary horizon shortly after sunset. (The drawings are by Jane Gear.) If you look at figure 6 you will see a simple landscape devoid of any but the most simple features; but it does have a powerful horizon, accentuated, first, by a bright sunset behind it while the foreground is somewhat starved of light, and, secondly, by being devoid of vegetation tall enough to obstruct the view. We have a clear impression

that, if we could reach any point on that clean, sharp horizon, all would be revealed. In other words, though it is very weak in the symbolism of the refuge, it is extremely strong in prospect, and, if that is what we want, it should provide an excellent vantage point.

We can, of course, strengthen the refuge symbolism by planting it up with trees (fig. 7), but wherever thick woodland covers the skyline we may impair the prospect symbolism, because the trees suggest an impediment to visibility.

There are two points on an undulating skyline which particularly tend to attract the eye. The lowest point commends itself as the viewpoint which can be attained with a minimum of exertion. The highest point may require a greater effort to reach it, but it is likely, other things being equal, to afford an even better view.

Figure 8 shows the effect of interfering with the prospect symbolism of the horizon by planting all over it except in the lowest section or "col." By putting in a road leading to that point we can further communicate the idea that that is the best place to aim at for a view over the top.

If on the other hand we fill the col with trees and clear the highest point of the ridge (fig. 9), our reading of the horizon changes and the summit becomes the focal point of our attention. We can even manipulate the horizon in such a way as to steer the imagination to the left (fig. 10) or right (fig. 11).

What actually lies behind the hill is still a matter of pure speculation of a kind commonly described in literature. Let me quote a few lines from Emily Brontë's novel *Wuthering Heights*. Cathy, at the age of thirteen, studies the place of prospect from the place of refuge:

> Sometimes, indeed, while surveying the country from her nursery window, she would observe: "Ellen, how long will it be before I can walk to the top of those hills? I wonder what lies on the other side—is it the sea?" "No, Miss Cathy", I would answer: "it is hills again, just like these."

What Cathy had encountered in the horizon was the cut-off point of the visible world, and what she experienced was a heightening of that curiosity which is always stimulated by the achievement of a modicum of information but which remains only partially satisfied. Already she had begun to fill in the picture—inaccurately as it turned out—from her imagination.

If you would like a couple of examples from the poets, compare

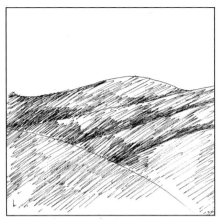

FIGURE 6. Drawings by Jane Gear

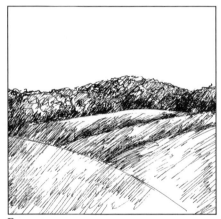

FIGURE 7.

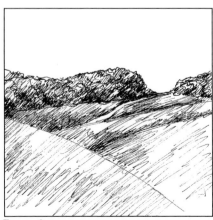

FIGURE 8.

these two. The Italian, Leopardi, remarking how his view was obstructed by a hedge, went on to say:

> But as I sit
> And look, within my thoughts I conjure up
> Unending space the other side of it.[6]
>
> (Leopardi, *The Infinite:* 3–5)

The imagination of Robert Frost, on the other hand, led him to build the opposite picture; the visual obstacle was to go on for ever:

> One of my wishes is that those dark trees,
> So old and firm they scarcely show the breeze,
> Were not, as 'twere, the merest mask of gloom,
> But stretched away unto the edge of doom.
>
> (Robert Frost, *Into My Own:* 1–4).

Looking at figures 6 to 11 you may already have begun to speculate on what lies beyond, and by extending the field of vision laterally (fig. 12), perhaps I can by suggestion inject into your imagination a measure of information which may affect your own speculative picture of the further landscape, leaving you to make your own assessment, in the light of your own experience, of the probability that the same kind of surface, a fragment of which we can now see on the left of the picture, may extend behind the hill. It may, of course, or it may not.

Once we have accepted that this

kind of natural environmental symbolism is able to influence the way we look at landscape we see that it can be exploited by architects or landscape architects in the selection of building sites or planting sites. A "small party of pine trees" (fig. 13), for example, to quote Siegfried Sassoon's phrase, of a kind which so magnetically captured his attention in the Kentish Weald, adds a tiny measure of refuge symbolism without suggesting any interference with its promise of prospect. Its architectural counterpart (fig. 14) can exploit the same locational advantage and in much the same way.

From here it is not a far step to turn to the works of the great painters and to look for examples of particular horizons being used symbolically to communicate particular messages relating to the subject of the painting. I have elsewhere put forward an interpretation of Bellini's *Agony in the Garden* (Appleton 1975: 151–153) in which the horizon is employed to reinforce the story line. It represents, I suggested, the landscape counterpart of the imminent Crucifixion, terminating a terrestrial experience and implying an extension of that experience into the world which lies beyond. The sharp clarity of the horizon and the clear-cut delineation of the minute objects projecting into the sky are clearly intended to communicate

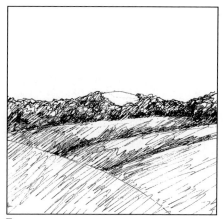

FIGURE 9.

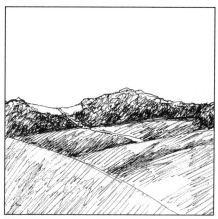

FIGURE 10.

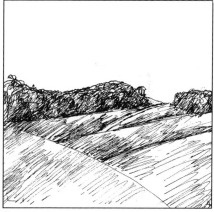

FIGURE 11.

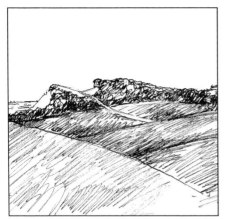

FIGURE 12. Drawings by Jane Gear

FIGURE 13.

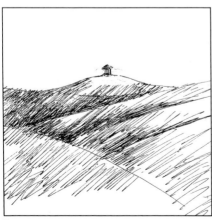

FIGURE 14.

the idea of great distance, while the brightness of the lower part of the sky, introduced in spite of the inconsistency which it creates with the angle of light falling on the rest of the landscape, accentuates the attractive power of the area beyond, as yet unvisited, to which the horizon is evocatively summoning the imagination.

To take another example, in Vernet's *Battle of Montmirail* (fig. 15), the sharpness of the horizon in the clear air accentuates the idea that, if we find the hazard symbolism of the battle too stressful, we can detach ourselves at any moment and escape to an infinite tranquility which lies beyond.

Just as a landscape provides a context for a narrative subject set within it, so a horizon provides a context for the landscape itself within a wider appraisal of space. These concepts of context, scale and particularly prediction, involving the relationship between past experience, present perception and future expectation, are the same concepts which find expression in that geographical orientation which is of such importance in survival behavior and is central to all exploratory activity. And even if we do not make the connection rationally, we must not be surprised if our innate pleasure-motivation propels us into this satisfying pursuit, or if artists follow its ground rules in devising pleasing landscape compositions.

We have seen that a particular significance attaches to those places where horizons rise into elevated summits. The link between the aesthetic and the strategic significance of such eminences has been noted by Gordon Orians:

> Flatness is usually regarded as boring and depressing to humans and we try to escape from flat areas if we can. Cliffs and bluffs attract us and this attraction is often associated with strong desires to climb to the top. Such behavior is probably valuable in terms of detecting game and potential enemies, but it is also intrinsically rewarding and is engaged in enthusiastically as recreation by well-fed, unthreatened persons with no intentions of hunting then or in the future. It suffices to climb and look out to stimulate a level of physical effort that is normally shunned. (Orians 1980: 60–61)

Elevations, then, particularly if they are conical or pyramidal in shape, have a powerful capacity for capturing the attention of the observer, and they are among the most common and persistent components of landscape painting of all periods and cultures. Figures 16 to 18 show examples merely to illustrate the kind of feature to which I am referring. One could without difficulty cite literally thousands. You will find them as prominent, if often distant, objects in such diverse painters as Breughel, Claude and Salvador Dali. Cézanne's obsession with the Mont Sainte Victoire (fig. 17) is legendary, and the Japanese painter, Hokusai, who painted a series of thirty-six scenes of Mount Fuji, used it almost like a trademark.

To some extent, of course, where actual landscapes are the painter's subject, the presence or absence of pyramidal peaks is determined by their occurrence in the landscape itself. Although painters of all periods have not scrupled to use artistic license and introduce them where nature has failed, the so-called "Canadian Group of Seven," founded some seventy years ago, was dedicated to bringing out the authenticity of the Canadian landscape; and, since its members came from eastern Canada, where the Shield Country is not typically endowed with such features, the pyramidal peak is not well represented in their work. Figure 18, however, shows what can happen when one of them goes west!

Not surprisingly, eminences of this kind have always lent themselves to architectural exploitation (fig. 19). The choice of such a site may well have a utilitarian explanation. The fortifications on the rock of San Marino (fig. 20), the tiny republic surrounded by Italian territory, derive much of

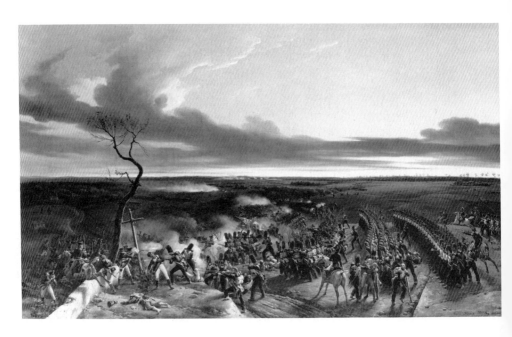

FIGURE 15. *The Battle of Montmirail* by Horace Vernet (1789–1863). The powerful horizon contends with the military action for the attention of the observer. Reproduced by courtesy of the Trustees of the National Gallery, London.

FIGURE 16. *Llyn-y-Cau, Cader Idris* by Richard Wilson (1713?–82). Reproduced by courtesy of the Trustees of the Tate Gallery, London. Wilson has been called "the English Claude" which, considering he was a Welshman, does not please the Welsh! Like Claude he frequently depicts pyramidal peaks as distant objects. Here, however, in one of his most Welsh landscapes, he presents one as the centerpiece of his composition. This is a true "pyramidal peak" in the geomorphologist's sense of the word. It is a sign of past glacial activity, together with arêtes, moraines and their associated impounded lakes, corries and hanging-valley features, all of which can be seen in the picture.

Figure 17. *Mont Sainte Victoire* by Paul Cézanne (1839–1906). Reproduced by courtesy of the Trustees of the Tate Gallery, London.

FIGURE 18. The apotheosis of the pyramidal peak! *Mount Lefroy,* 1930, by Lawren Stewart Harris (1885–1970). Reproduced by permission of the McMichael Canadian Art Collection, Kleinburg, Ontario.

FIGURE 19. Volcanic Plug Surmounted by a Chapel at Le Puy in the Massif Central, France. Photo by Jay Appleton.

FIGURE 20. Fortifications on a Precipice, San Marino. Photo by Jay Appleton.

their impregnability from the precipice which they surmount. From the point of view of convenience in terms of water supply, ease of access from the surrounding fields, and so on, this is about as unpromising a site as one could find; but if defense is perceived as the primary objective on which the maintenance of a comfortable life ultimately depends, these inconveniences may be acceptable. In our symbolic terminology prospect, refuge and hazard are first and foremost strategic concepts to do with immediate behavioral responses to environmental challenges. What could be more natural, therefore, than to find them expressed so powerfully in strategic fortifications? The immediate juxtaposition of the enclosed fortified space and the adjacent precipice dramatises the role of refuge while the strength of the prospect symbolism derives largely from the immense elevation of the site itself above which the artificially constructed vantage points, the towers, rise even higher.

Figure 21 shows an even more impregnable site, the refuge symbolism of the castle deriving strength from its juxtaposition with the precipice. Both here and at San Marino, however, it should be noted that the precipice itself is not functionally the hazard against which protection is sought. That hazard is the possibility of intrusion by unwanted, even hostile elements, and the highly hazardous cliffs are paradoxically pressed into service in actually strengthening the ability of the structure to exclude unwelcome intruders. This is yet another example of that symbolic ambivalence which we have already noted. What may be a hazard to ourselves may become an ally in furtherance of our self-protection if we can enlist it in the task of repelling an even greater hazard.

Long after a fortified structure has ceased to serve the defensive function for which it was built, it may continue to evoke powerful aesthetic responses in societies with very different cultural attitudes and values, because, if the original has been constructed to maximize the strategic advantages inherent in the site, it should not surprise us to find that it appeals aesthetically to people in whom that sense of strategic awareness is still perpetually active and responsive to the same underlying system of natural symbolism.

So any object, natural or artificial, rising into the sky commends itself as a symbol of prospect. Through it every kind of cultural symbolism may find expression, Christian, for instance (fig. 22), Muslim (fig. 23), or

Marxist (fig. 24). With increasing opportunities for the worldwide spread of innovative ideas, twentieth-century architecture has evolved its own technological idioms which may now be found almost anywhere (fig. 25); but all of these manifestations of cultural symbolism are exploiting the simple underlying fact that objects rising high above the surrounding terrain compel our attention, whether we encounter them in the Black Forest, in Cairo, in Budapest or anywhere else.

In all these last examples I have stressed the prospect symbolism which can be expressed by buildings, but the primary function of most buildings is as places of refuge. The ordinary domestic residence (fig. 26) represents the culmination of an evolutionary program of development which can be traced right through from the cave dwelling. It is not merely the successor of the nesting place, it *is* the nesting place proper to the species into which *Homo sapiens* has now developed. Of course it takes on a vernacular idiom peculiar to its time and place, but wherever it is encountered its function is to furnish whatever is needed for the raising of a family, including shelter, privacy and a greater measure of security than is to be found elsewhere. Emotionally it is capable of inducing feelings of attraction which we can recognize, if not as identical with the homing instincts of other creatures, at least as their closely related counterparts.

What I should now like to examine a little more closely is not so much the function of buildings as places of refuge but rather the symbolism through which they communicate a sense of such a function to those of us who observe them.

A fortified building implies by its very existence a capacity to exclude all who are not intentionally admitted. Other things being equal, the more powerful that capacity, the stronger the sense of refuge. But in terms of "affordance" we read its symbolic message very differently, depending on whether we perceive it as a potential refuge for us; a façade which appears totally impenetrable may simply not work for us as a symbol of refuge.

By comparing figures 27 and 28 it can be seen that the refuge afforded by the Red Fort in Delhi, which would be militarily much less defensible, is visually far more immediately attainable than that of the semi-fortified textile mill. The interface between inside and outside is weakened almost to the point of elimination in the Indian building, yet the visual contrast

FIGURE 21. The Alcázar, Segovia, Spain. Photo by Jay Appleton.

FIGURE 22. Cultural Symbolism 1. Cathedral spire in Freiburg-im-Breisgau, West Germany. Although the cultural symbolism represented by this structure contrasts strikingly with that of figures 23, 24 and 25, they all rely on the same basic compositional device, namely the elevation above the horizon of an eye-catching architectural object or objects which would arouse attention at any place and in any period because it is a wholly natural phenomenon central to the processes of environmental perception. Photo by Jay Appleton.

FIGURE 23. Cultural Symbolism 2. Even in silhouette this Cairo skyline unmistakably proclaims an Islamic cultural heritage. Photo by Jay Appleton.

FIGURE 24. Cultural Symbolism 3. Most of the countries of Eastern Europe contain monuments to their "liberation" by the Soviet armed forces. They belong to a particular period of cultural history and they reflect a particular socio-political philosophy. This one is in Budapest, Hungary. Photo by Jay Appleton.

FIGURE 25. Cultural Symbolism 4. Within the second half of the twentieth century, the tower block has spread the symbolism of modern technology all over the world at the expense of local vernacular characteristics and national architectural traditions. Although individual high-rise buildings may vary greatly in the details of their design, they all belong to an architectural style which is a product of new technological invention coupled with the twentieth-century economics of downtown real estate. Because similar conditions have burgeoned in large cities all over the world, the same architectural solutions tend to be employed. This is a block of council flats in Hull, England. Photo by Jay Appleton.

FIGURE 26. The Symbolism of Refuge. Cottages at Bishop Burton, Humberside, England.
Photo by Jay Appleton.

between the dark shadowy interior and the open terrain of the foreground powerfully excites a sense of refuge of a kind which the more securely fortified building may never manage to awaken.

The possibilities for variation on this theme are infinite. In comparison with the Red Fort, it is much more common for large public buildings to concentrate the opportunity for access in a very limited number of large apertures. Some modern shop designers have got the message that the emotional attraction towards the symbolism of the cave has not disappeared from our species (fig. 29). On the other hand long, uninterrupted walls (fig. 30) are perceived as impediment hazards, effectively cutting off any possibility of escape through 180 degrees of arc.

Much modern architecture seems to me to pay too little attention to visual penetrability. It is actually possible to enter the Broad Marsh shopping centre in Nottingham, England through small apertures in the wall shown in figure 31, but this is not at first visually apparent. The overall impression is that we are intended to keep out.

What I believe is disturbing about large impenetrable façades is the feeling they communicate that they threaten our opportunities for escape. They make us feel claustrophobic, trapped (fig. 32). Their apotheosis is to be found in the prison wall. At greater distances they may still appear to exclude us but not to confine us, so we don't experience the same sense of oppression (fig. 33); the imagination is not alienated in the same way but is free to enjoy the powerful expressions of prospect and refuge so effectively combined in the towers, turrets and fortified vantage points of all kinds. These features are so attractive aesthetically that we find them incorporated in civil buildings long after they have become functionally irrelevant.

A good example would be the Scottish baronial style. The history of the castle in Scotland as a fairly sophisticated fortification goes back at least to the Middle Ages, but it reached its most perfect expression in a group of castles built in the hinterland of Aberdeen in the closing decades of the seventeenth century (fig. 34), already almost too late, even in Scotland, to be functionally meaningful as fortifications. But as symbolic expressions of those basic concepts of prospect and refuge they were very impressive, and nineteenth-century architects delighted in incorporating their features in buildings of every kind. One of the best known is the

FIGURE 27. Textile Mill, Cromford, Derbyshire, England. Because the local cottage textile workers felt threatened by the new inventions of the late eighteenth century, the organized smashing of machinery was one of the potential hazards against which Richard Arkwright (1732–92) had to insure himself when he built this mill. It not only looks like a fortified building, it is one. Photo by Jay Appleton.

FIGURE 28. The Red Fort, Delhi, India. Photo by Jay Appleton.

FIGURE 29. Shop Front, Lowgate, Hull, England. The symbolic significance of the name of the store may or may not have impressed itself on the awareness of the architect, but it takes us right back to the homemaking imagery of our cave-dwelling ancestors. Photo by Jay Appleton.

FIGURE 30. Dockside Warehouses in Hull, England. The impenetrable wall on the right denies the strategic advantages of both a clear visual field and an opportunity for escape. Photo by Jay Appleton.

FIGURE 31. Rear View of the Broad Marsh Shopping Centre, Nottingham, England. Photo by Jay Appleton.

residence built in the 1850s for Queen Victoria at Balmoral (fig. 35). The English Victorians were obsessive reviewers of earlier styles and saw nothing incongruous in furnishing not only railway stations but also the portals of tunnels with towers and battlements.

It may help us also to evaluate other architectural devices if we can see them in terms of this kind of symbolism. For example, the fashion for facing large buildings with reflecting glass (fig. 36) may be successful in strengthening their prospect values. They often present huge and highly impressive portraits of the townscape behind the observer, but they do nothing for the refuge values of a building. The façade is no more penetrable than Arkwright's cotton mill (fig. 27). I am not suggesting that this is either good or bad, merely that architects may possibly find some benefit in a theoretical understanding of the ways in which their workmanship is likely to affect emotionally the perceiving public who will have to interact with it for as long as it remains standing.

One of the most important manifestations of the symbolism of opportunity concerns the recognition of potential channels of movement. I need scarcely stress the strategic importance of an ability to make a quick and accurate appraisal of the surrounding terrain in these terms. Like other survival behavior it is productive of satisfaction for its own sake. The initial reconnaissance, the identification of alternative paths and the selection of the most advantageous are all sources of pleasure even before the exploratory journey itself begins.

All kinds of challenge to the imagination present themselves, raising elementary but important questions. A very common case is to be found in what I have elsewhere (Appleton 1975) called "the deflected vista" (fig. 37), in which a potential channel of movement is disclosed but the view along it is terminated by a bend or deflection. What distinguishes it is not its cultural context, not even whether it occurs in a natural, a planted, or an architectural medium (fig. 38), or on a small or large scale (fig. 39), but the curvilinear feature by which it stimulates then frustrates curiosity— a geometrical alternative, if you like, to the horizon which, as we have seen, does the same thing in a different plane.

Route selection is as important in landscape aesthetics as in survival behavior, and of particular significance are the crisis points where decisions have to be made which way to go. I have a clear recollection of

FIGURE 32. Street Scene, Delhi, India. The uncomfortable feeling aroused by the impediment hazard on the right (cf. figure 30) is accentuated by the suspicion that innumerable pairs of eyes could be watching from the tiny windows. It is a straight reversal of the desirable "prospect-refuge" situation in which we are at a strategic advantage when we can, in the words of Konrad Lorenz, "see without being seen." Photo by Jay Appleton.

Figure 33. Château de Chillon, Vaud, Switzerland. Photo by Jay Appleton.

FIGURE 34. Craigievar Castle, Grampian, Scotland. One of the great late seventeenth-century "Castles of Mar," a major source of inspiration for the later "Scottish Baronial" style (cf. figure 35). Photo by Jay Appleton.

FIGURE 35. Tower at Balmoral Castle, Grampian, Scotland. A residence constructed on Deeside for Queen Victoria in the Scottish Baronial style. Drawing by Keith Scurr.

FIGURE 36. Office Buildings, Hull, England. The opaque glass effectively produces a vast picture of whatever is reflected in it but does not symbolically suggest that those of us who are outside the building could actually enter it. Photo by Jay Appleton.

walking through the University of Washington Arboretum in Seattle a few years ago with a group of graduate students from the Department of Landscape Architecture. It was a kind of peripatetic seminar, and after about three minutes we reached the first fork in the path. There we began a discussion about the relative attractions which each of us felt for the alternative options and about the reasons which led us to our individual decisions. This single question about the connection between preferences and action kept us there for the rest of the hour allowed in our schedule.

On the negative side it is in the context of route selection also that we should see the impediment hazard to which I referred earlier, since it has the effect of closing options rather than opening them up, thereby causing feelings of anxiety and frustration rather than of pleasurable expectation. Among the many kinds of impediment hazard we encounter in painting, river-lines and other water margins are the most common. Like all symbols in landscape they can be highly ambivalent and their other symbolic meanings may be perceived as more important than their functions as potential obstacles; nevertheless that function is always there.

Whatever form an impediment hazard may take, a particular significance attaches to any point at which it can be overcome, as is only to be expected if we see environmental perception as the exploration of environmental opportunity. Openings in walls, holes in hedges or steps surmounting cliff faces inevitably commend themselves to our notice. Of all these breaches in impediment hazards by far the most important in landscape painting are those which enable rivers, which otherwise interpose an obstacle to passage, to be crossed. Small boats, ferries and so on may be attractive subjects in their own right but they also discharge a powerful symbolic function. Constable's *Hay Wain* is probably the most famous of a large number of paintings of fords. But the most common device for spanning water is the bridge. Once again, it is not restricted to any particular school, period, nationality or culture. If you are not convinced, pay a visit to any large art gallery with a comprehensive collection of landscape paintings.

This fascination with the bridge as a subject is not fortuitous. It is a powerful symbol of opportunity. It illustrates as well as anything the extent to which our attention is involuntarily captured first and foremost by

FIGURE 37. Deflected Vista 1. The approach drive to Muncaster Castle, Cumbria, England, arouses exploratory expectations which are not immediately fulfilled. Photo by Jay Appleton.

FIGURE 38. Deflected Vista 2. Street scene in Briançon, France. Compare this deflected vista in a built environment with that shown in figure 37 where the flanking screens, though carefully designed, are formed by plant materials. Photo by Jay Appleton.

FIGURE 39. Deflected Vista 3. Glaciated valley near Ailefroide in the Massif du Pelvoux, French Alps. Although the scale and almost all the visible features are very different from those of figures 37 and 38, the expectation of a further visual experience is no less effectively aroused by a similar basic layout of a central curvilinear "void" flanked by opaque "masses." Photo by Jay Appleton.

objects, conditions, or situations which are of strategic significance, and it serves to demonstrate the central theme of this book, that our habits of environmental perception can be seen as providing a direct link between our evolutionary history, as described by the scientists, and those aesthetic values which we see as belonging to the world of the arts.

# 3 THE PROOF
## *of the*
# PUDDING

THERE IS AN OLD proverb that the proof of the pudding is in the eating, and even if you have by now begun to understand what the recipe is, you are still entitled to ask whether it works. Let me remind you again, however, that I am not attempting to prove anything, merely to place before you enough evidence to persuade you to keep an open mind on these matters at least until you feel able to come to some conclusion on the basis of your own evaluation of such evidence and whatever other examples you may draw from your own experience.

In the field of landscape aesthetics there are some questions which lend themselves to investigation by controlled experiments in which the researcher is able to regulate all the relevant variables. Much of what we now know about preference for particular landscape types or features has been derived from questionnaires addressed to groups who have been shown landscape pictures and asked to evaluate them comparatively. The researchers conducting the experiments have chosen the groups, preselected the pictures, determined the scale of values by which they are to be judged and decided on the statistical tests to be applied to the resulting data; but we can only apply such controlled experiments to a very limited range of questions. We can't ask the ancient Greeks about their attitude to the forest or the first settlers on Puget Sound about the feelings evoked by Mount Rainier. We can only make the best practicable use of the records which they happen to have made, which happen to have survived, and which we happen to have discovered.

If, therefore, we are to test any hypothesis which postulates a link between evolutionary processes, environmental perception and aesthetic

values, we are likely to have to supplement a few controlled experiments with a heavy reliance on circumstantial evidence, none of which is, by itself, conclusive. I propose at this stage to follow my own advice and enlist the aid of "other people, with different kinds of expertise" in the hope that some readers at least will be motivated to examine these ideas "in the light of their own several kinds of understanding." The best way to contact such "other people," (who might include you!), is to take a number of selected cases, little cameos, "vignettes," if you like, drawn from the literary and visual arts, which will illustrate the range of different sources from which such circumstantial evidence may be drawn. In this way it may be possible to find at least one of these vignettes which will strike a chord of recognition in some readers. Inevitably this will result in this chapter appearing somewhat disjointed, but you may find this more acceptable if you understand what I am trying to do!

I should like to begin with an example which brings us back to a point I raised in chapter 1, namely what we may call the "nature versus nurture syndrome"—the idea that any one case must be attributable either to heredity or environment. A fairly typical comment would be this, which comes from an English landscape architect:

> My main concern is how do we know when to "buy" an evolutionary rather than a cultural explanation? (Brotherton, 1986: 23)

The question is framed in a way which, although it may not actually say so in so many words, clearly implies that we have a choice, either evolution or culture.

The misconception which underlies this implication can nowhere be better illustrated than in that art which involves the actual contrivance and manipulation of the material environment, namely, landscape architecture or landscape design.

In the grounds of the Palace of Versailles we can see how important are rigid and regular geometrical shapes in the design of the grounds. At the Palais du Petit Trianon (fig. 40) these principles are particularly well demonstrated. The forecourt as well as the façade of the building is symmetrically disposed about a central axis, each side being a mirror image of the other. The lawns and paths, the ornamental trees and water, all conform to the geometrical perfection of the rectangle or the circle.

If, however, we walk up the steps to the side of the terrace and look out to the left (fig. 41), we see a later garden which embodies every opposite characteristic. It is called "Le Jardin Anglais," and conforms to the style pioneered in England in the eighteenth century. It is irregular and asymmetrical and it gives the impression (quite erroneously, of course) of being unplanned, of occurring accidentally under the guidance of nature rather than Man.

I mentioned in chapter 1 the sort of philosophical problems we encounter if we postulate that beauty resides either in regularity and order or in irregularity and disorder; both gardens are admired by and give pleasure to those who visit them.

Now those who argue for a cultural explanation will say that, to understand this dichotomy, we have to place these styles in the context of the social history of western European civilization, and of course they are right. The great formal design of André le Nôtre at Versailles has to be seen as a symbolic statement about the subjugation, not only of nature by man, (and, notwithstanding the sensitivity of the feminists, in seventeenth-century France I mean "man"), but also of the whole French social hierarchy by the French king.

On the other hand, if we look at the informality of the style which succeeded it, having been developed by the great English landscape architects, William Kent, Capability Brown and later Humphry Repton and their contemporaries, it makes sense to see this only in the cultural context of the eighteenth century, in the philosophical context of the Enlightenment in France and in the political context of the liberal Whig aristocracy in England. By that time a reaction had set in against overregimentation. Geometrical tyranny was seen as a symbol of social and political tyranny, while the freer style of design symbolized a more liberal attitude to the role of the individual human spirit within the natural order, an attitude which, towards the end of the century, was to find its fullest expression in the Romantic Revolution.

But both of these styles, different as they are to the eye, present the observer with arrangements of what the landscape architects call "voids" and "masses"—open channels of visibility bounded by opaque objects of whatever material, living or dead, which impose inescapable restrictions on our organs of perception. The basic symbolism of the prospect and the

Figure 40. Le Petit Trianon, Versailles, France. Note the geometrical regularity typical of seventeenth- and early eighteenth-century landscape design and compare it with figure 41. Photo by Jay Appleton.

FIGURE 41. Le Jardin Anglais, Versailles, France. This is the view you would see if you ascended the central staircase shown in figure 40 and proceeded to the left-hand end of the terrace. Note how it is the very antithesis in almost every respect of the formalism of the earlier design. Photo by Jay Appleton.

refuge which underlies both kinds of design is essentially the same. What is so strikingly different is the cultural idiom through which it is given expression. When the new fashion arrives, Nature, like any other lady released from her restricting corsets, suddenly assumes a more irregular, informal, natural, and, some might say, interesting shape.

To pose this as an either-or question, then, requiring us to opt for either nature or nurture, heredity or environment, the innate or the learned, is to render it unanswerable. Suppose we were to ask ourselves whether we should "buy" an evolutionary or a cultural explanation of Gainsborough's well-known painting of Mr. and Mrs. Andrews (Fig. 42). It is certainly loaded with cultural symbolism, and we have to see it in the socio-historical context of the culture to which it unmistakably belongs. Mr. Andrews is an eighteenth-century member of the English landed gentry, and Gainsborough shows him among his material possessions, including his wife, (who by her attire places herself in the chronological context of that constantly changing phenomenon, ladies' fashion), his gun (symbol of his recreational interests), and the broad acres of his estate. The stockproof hedgerows and the field gates tell us something about the agricultural enterprises and management practices of a mixed farming region, and so on.

When, however, we look into the distance, our eyes are guided by habits of perception which are not time- or place-specific, but transcend the culture of the eighteenth century as also of our own period. A shallow valley leads us into the distance until visibility is cut off by a deflection round a small mass on the right which would be recognizable as a place of refuge in any period. In this eighteenth-century context we can reasonably guess that it was almost certainly preserved and in all probability planted to provide nesting sites (refuges) for the game birds which Mr. Andrews evidently enjoyed shooting and which, if they were not able to find habitats appropriate to their natural requirements, would be expected to fly away to seek better cover on the estate of some neighbouring squire with a better understanding of those bonds of attraction which link creatures to places.

Now how do we sort all that out in terms of "nature or nurture"? The influences of heredity and environment are inextricably bound together in a single picture. Even if we wanted to, how could we quantify the relative importance of each? The crucial point is to recognize that if both

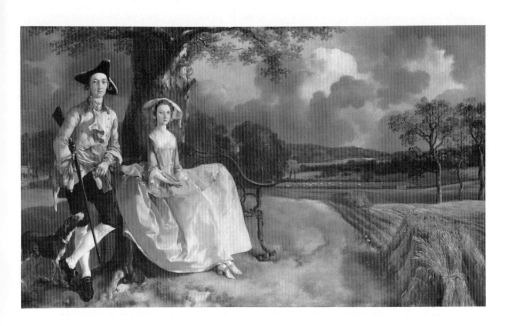

FIGURE 42. *Mr. and Mrs. Andrews* by Thomas Gainsborough (1727–88). Reproduced by courtesy of the Trustees of the National Gallery, London.

influences are operative in whatever degree, we need to understand as much as we can about the general principles which govern both.

I should now like to turn to my next little cameo to see whether the concept of natural as opposed to cultural symbolism can add anything to a topic within the field of art history as developed in a well-known paper in the literature. The paper in question, by Lorenz Eitner, is entitled "The Open Window and the Storm-Tossed Boat: An Essay in the Iconography of Romanticism" (Eitner 1955). In the article Eitner reproduces six pictures of views through open windows varying in date between 1815 and 1858 and two others showing variants in which the view itself is implied rather than portrayed. *Frau am Fenster* by Caspar David Friedrich, here reproduced as figure 43, is one of them.

Writing in the *Catalog* of the Friedrich Exhibition at the Tate Gallery in London in 1972, Helmut Börsch-Supan says:

> The figure seen from the back represents Friedrich's wife Caroline, and the room is the studio that Friedrich used after 1820. The view extends over the River Elbe to the opposite shore, which symbolizes paradise. The cross-like shape formed by the supports dividing the window pane becomes a Christian symbol, and the dark, close interior represents the terrestrial world. (Börsch-Supan 1972: 77)

Cultural symbols of this kind are found in all Friedrich's paintings. The moon is a symbol of Christ, the woodland path is the course of human life, and so on, but all this symbolism is grafted on to an underlying system of meanings which are not dependent on human attribution.

The question which Eitner addresses is why these two subjects, the open window and the storm-tossed boat, should have assumed such popularity among artists in the first three decades or so of the nineteenth century. This is not the place to recount in any detail his argument, most of which, as far as it goes, I would accept. He places the theme of the open window in its cultural context, using a terminology familiar enough to art historians—how it fits into the classical/romantic dichotomy, whether it is or is not a form of *genre* painting, how much it owes to the seventeenth-century Dutch, how far it is to be read as social symbol, as allegory, and so on. He does indeed recognize the importance of the contrast between the domesticity of the immediate foreground and the "themes of frustrated longing, of lust for travel or escape which runs through romantic literature," even quoting in translation Eichendorff's poem *Sehnsucht:*

The stars shone so golden.
I stood at the window alone
And heard from a distance
A posthorn in the quiet night.
My heart ached within me
And I thought to myself:
Oh, if only I could travel along
Into the marvellous summer night.
(Eitner, 1955: 286)[7]

A "here-and-there" poem if ever there was one!

What I find frustrating is that Eitner seems to see this as an entirely new subject, like a comet that has suddenly appeared from nowhere, rather than as a new fashion in the idiomatic expression of a phenomenon which is as old as, indeed older than *Homo sapiens* itself. Once we see it as a powerful, if simplistically obvious, expression of the prospect-refuge complement, we alter the question, which is not why the subject should have become popular at this time, but why a perennially, biologically crucial facet of environmental perception should have taken this form. We still haven't answered the question, but we have put it into a more realistic perspective if, instead of seeing it primarily as an expression of German Romanticism, we see it as an expression *through* German Romanticism of a ubiquitous and enduring ecological process.

The storm-tossed boat (figs. 44 and 45) is an obvious manifestation of the symbolism of the hazard. Eitner cites many writers who between them postulate numerous explanations, allegorical, political, theological, fantastic, each affording more than one line of interpretation. The nearest he comes to an ethological explanation is when he contrasts the two images, the open window and the storm-tossed boat. "Nature," he says, "appears as a lure in the one, as a threat in the other." We can take it a stage further once we understand that the threat is also a lure. The apparent paradox of an enjoyable fascination with danger and with the fear of imminent death becomes much easier to handle if we see that fascination as just one component of a pleasure-motivated mechanism for driving us to inform ourselves as comprehensively and realistically as we can, and without putting ourselves at undue risk, about the nature and extent of those hazards which we need to avoid if we are to further our chance of survival.

FIGURE 43. *Die Frau am Fenster* by Caspar David Friedrich (1774–1840). Staatliche Museen Preussischer Kulturbesitz, Nationalgalerie, Berlin (West).

FIGURE 44. The Storm-tossed Boat 1. *Christ on the Sea of Galilee* by Eugène Delacroix (1798–1863). Reproduced by courtesy of the Walters Art Gallery, Baltimore.

FIGURE 45. The Storm-tossed Boat 2. *The Shipwreck* by J. M. W. Turner (1775–1851). An extreme representation of the symbolism of hazard. Reproduced by permission of the Trustees of the Tate Gallery, London.

The symbolism of the hazard, like that of prospect and refuge, can find expression in an infinite variety of forms and a range of intensity extending from the almost nonexistent to the terrifyingly dramatic, and it is easy to recognize individual artists who developed a particular feeling for it and particular styles in which to portray it. Turner (1775–1851) was much more at home with it (fig. 45) than his predecessor, Gainsborough (1727–1788) or even more so, his near-contemporary, Constable (1776–1837), who tended to see beauty in more gentle landscapes and to play down his representations of real danger (Paulson 1982). But if we are looking for a really robust use of hazard symbolism we should find it hard to beat the English painter John Martin (1789–1856). Though slightly younger than Turner and Constable, Martin was active at approximately the same time, and he developed an interpretation of Romanticism which drew heavily on a variety of visual resources. In his more dramatic fantasies we can see resonances of Hieronymous Bosch but also of the furnaces, architecture and civil engineering of the Industrial revolution (Feaver 1975). For the most potent agencies of terror, however, he still turned to Nature herself, clouds, lightning, precipices, tumultuous waves and the immensity of space (figs. 46 and 47).

In spite of the absence of color, some people may find a more chilling expression of hazard in the series of fourteen and eventually sixteen copperplate etchings of prisons published under the title *Carceri d'Invenzione* by Piranesi (figs. 48 & 49). Whereas many people found and possibly still find Martin's representations of hazard so extreme that they could hardly be taken seriously, these huge vaults of incarceration, extravaganzas though they may be, and notwithstanding what Wilton-Ely calls "a system of conflicting illusions preventing one from adjusting to the environment at any one moment" (Wilton-Ely 1978: 83), are still wholly credible. Although they existed only in the imagination of the artist, if we want to understand them either as social institutions or as architectural compositions, we need to place them in the context of mid-eighteenth-century Italy. But we must not allow ourselves to be so dominated by a concern with cultural symbolism that we fail to ask ourselves why it is that every single one of the sixteen plates depicts these vast spaces *from below*. There is no technical reason why these staircases and ladders should not be shown from above, so one might expect some to be shown one way, some the other. We could look down on the poor devils in the dungeons and

FIGURE 46. *Sadak in Search of the Waters of Oblivion* by John Martin (1789–1854). Reproduced by courtesy of Southampton City Art Gallery, Southampton, England.

FIGURE 47. *The Great Day of His Wrath* by John Martin (1789–1854). Reproduced by permission of the Trustees of the Tate Gallery, London.

FIGURES 48 and 49. *Carceri D'Invenzione.* Two of the prints (First State, ca. 1760, Numbers VI and X) from the series of imaginary prison scenes by Giovanni Battista Piranesi (1720–78). From a private collection.

pity them if we chose, but we would not be one of them. In these pictures, to the grim impenetrable enclosing walls, the vast disorienting spaces, and the sinister engines of torture, we must add that sense of inferiority which naturally comes from the strategically disadvantageous position of the underdog, wherever encountered. To have to fight against the natural force of gravity as well as the social force of authority is depressing indeed. It is in our nature not to like being at the bottom, at least when we are under threat.

Not all hazard imagery is as gloomy as this, and I would remind you again of that ambivalence which is so characteristic of all landscape symbolism. I referred earlier to rivers and other bodies of water which can communicate all kinds of symbolic messages and consequently may evoke all kinds of different feelings. One of their most important roles is that of an impediment hazard, but just as the castle builder may enlist the aid of the precipice hazard, so also of the water hazard (fig. 50).

In my next example I should like to direct your attention not so much to a subject as to a technique, that of handling the use of light and shade. In its most extreme form the contrast between light and shade is known as *chiaroscuro* and we are most familiar with it in portraiture. It is a simple fact of the psychology of perception that we tend to notice brightly illuminated objects more than dark, shaded areas, and painters like Caravaggio and Rembrandt exploited this technique to great effect. There are problems in applying the technique to landscape because of the difficulty of excluding light from large areas, but it can be done. The photograph reproduced as figure 51 was taken at midday in the middle of a large and very dense plantation of rhododendrons. The purpose of the *chiaroscuro* technique is to maximize the availability of light at the point where it can reinforce the most important part of the subject, and although this degree of contrast may be exceptional in outdoor scenes, some variation of light intensity can always be achieved to regulate the balance of symbolism.

Figure 52 shows a church spire projecting out of a wood. The prospect symbolism of the spire does not in any way weaken the sense of refuge built up by the association of the church and the wood. In this painting, however, Jacob van Ruisdael seems to have suppressed this symbolism by giving much greater prominence to the brightly illuminated field. He could have restored the emphasis to the church by flooding it with the brightest patch of light, but there is a sense in which the concept of refuge

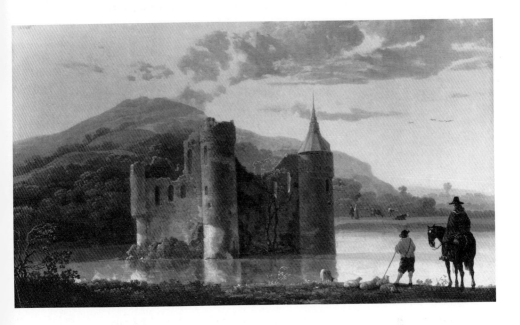

FIGURE 50. *Übbergen Castle* by Aelbert Cuyp (1620–91). The terms "prospect," "refuge" and "hazard" comprise a kind of shorthand for a highly complex system of symbolic messages which communicate information about strategic opportunities. Such messages are the necessary precursors of environmental adaptation, but they are often highly ambivalent and the challenge of their interpretation, conscious or subconscious, is one of the things we enjoy in the contemplation of landscape. The landscape painter can use this ambivalence to appeal through the eye to the observer's environmental awareness. Reproduced by courtesy of the Trustees of the National Gallery, London.

FIGURE 51. Girls in a Rhododendron Plantation, Brownsea Island, Dorset, England. Photo by Jay Appleton.

FIGURE 52. *An Extensive Landscape with Ruins* by Jacob van Ruisdael (1628/9–82). Reproduced by courtesy of the Trustees of the National Gallery, London.

FIGURE 53. *A Landscape with a Ruined Castle and a Church* by Jacob van Ruisdael (1628/9–82). Reproduced by courtesy of the Trustees of the National Gallery, London.

is more closely associated with shade rather than light, so such a solution, while drawing attention to the refuge area, would have weakened the refuge effect. An alternative option, which Ruisdael chose in another painting of the same place (fig. 53), was to put the church and the wood under a heavy cloud shadow with brighter light behind, thereby creating a silhouette. The symbolic objects are the same in both paintings; the strength of their symbolism and consequently the whole feeling induced by the picture is altered solely by the manipulation of the light. The cultural context is time- and space-specific—a particular landscape in seventeenth-century Holland; the habits of perception of the human eye, which are enlisted to achieve the artist's objective, are part of a natural phenomenon which is not time- and space-specific.

The most extreme examples of the use of *chiaroscuro* in landscape are to be found in night scenes. This is the phenomenon I have called "inversion" (Appleton 1975: 136–140), when the normal situation, in which the sky is rich in prospect-values, is reversed; the sky becomes a huge matrix of refuge symbolism within which little prospects are brought to life by fires and other sources of artificial light. With the addition of music this has given birth to the relatively new art form of *son et lumière* (fig. 54).

I should like now to turn to something quite different, taking just one short poem and examining it as an expression of the kind of symbolism we have been considering. The English poet John Clare wrote chiefly about the countryside of the Fenland edge, near Peterborough, Northamptonshire, and he frequently used words from the local dialect. In the little poem which follows there are only two words which require translation. The word "pips" or "peeps" means the bell of a flower, in this case the cowslip. The other word is "clock-a-clay" which is in fact the title of the poem. The clock-a-clay is what we call the ladybird (ladybug), a little round beetle, red with black spots.

I am not, of course, going to suggest that you should regard this as a scientific study of the psychology of the beetle. It gives us some insight into the mind, not of the beetle, but of John Clare, who is here transposing his own habits of environmental perception onto a diminutive scale and verbalizing them in his own simple, almost nursery-rhyme style. This tiny creature in its safe refuge, swinging on top of a pliable stalk, congratulates itself on being invulnerable to the persistent threats of the hostile elements. What I want you to do is just concentrate on the words

and see how Clare handles the conceptual trilogy of prospect, refuge and hazard.

> In the cowslip pips I lie,
> Hidden from the buzzing fly,
> While green grass beneath me lies,
> Pearled with dew like fishes' eyes,
> Here I lie, a clock-a-clay,
> Waiting for the time of day.
>
> While grassy forest quakes surprise,
> And the wild wind sobs and sighs,
> My gold home rocks as like to fall,
> On its pillar green and tall;
> When the pattering rain drives by
> Clock-a-clay keeps warm and dry.
>
> Day by day and night by night,
> All the week I hide from sight;
> In the cowslip pips I lie,
> In rain and dew still warm and dry;
> Day and night and night and day,
> Red, black-spotted clock-a-clay.
>
> My home shakes in wind and showers,
> Pale green pillar topped with flowers,
> Bending at the wild wind's breath,
> Till I touch the ground beneath;
> Here I live, lone clock-a-clay,
> Waiting for the time of day.

There are few poets whose work has been more profoundly affected by the specific environment of childhood experience than Clare, and much of his poetry expresses this exactly, as Barrell has so clearly shown (Barrell 1972), but these little verses, though couched in an idiom belonging to his own time, place and indeed individual personality, describe the enduring psychological basis of survival behavior and bring out the pleasure and self-satisfaction of success.

It is now time to look back over the course we have pursued to see whether we can find some perspective into which our thoughts can be fitted. What I have specifically tried to do has been to concentrate on *symbolism* as a key to our understanding of landscape in the arts and

Figure 54. The Acropolis, Athens, during a Performance of *Son et Lumière*. Photo by Mark Appleton.

particularly to establish the difference between two quite different types of symbolism to which I assigned the names *cultural* and *natural* respectively. First, however, it was necessary to draw your attention to some of the difficulties which arise from the suspicions and misgivings of people trained in one habit of thought when they are confronted by arguments couched in the language and traditions of another, and the approach we have been following may well involve their rethinking some of the very basic features of their respective methodologies.

It has, for instance, been a major concern of philosophers, very properly, to pursue their investigations within a system of rules devised to exclude the intrusion of fallacy, rather as the town builders of San Marino built their town (fig. 20) to exclude unwanted intruders. If, however, the present inhabitants of that town wish to reap the commercial benefits of their historic heritage, they may find that the structures erected to keep people out are unhelpful when the need is to encourage a large influx of motorized tourists.

So we must expect to find among philosophers some whose sensitivities are likely to be upset by the impact which unfamiliar and perhaps more practically based techniques of investigation are bound to have on modes of discourse that commonly originate in and continue to be based on abstract concepts (Langer 1953: 5). Or again, art critics may very reasonably feel that, if biologists ask for scientific explanations of those metaphors in which they transact a great deal of their business, there is the implication that the critics are incapable of rational thought and logical expression. However unjustified their fears, we must not be surprised if they react defensively.

On the other hand, the scientists may also need to make some concessions. For instance, they will often show a reluctance to publish a new hypothesis until it has been empirically tested to their satisfaction. Generally speaking this is entirely proper, and many so-called scientific theories have come to grief precisely because more has been claimed for them than has been supported by such testing. Where the proposers of theories are competent to carry out the appropriate tests themselves, it is clearly desirable that they should do so. When, however, we are dealing with a multidisciplinary investigation, involving both the arts and the sciences, (and many branches of each), it may be that progress depends on communicating the idea as early and as widely as possible, not, of course,

presenting it as if it had already been scientifically demonstrated, but throwing it around as a provisional hypothesis for other people with different kinds of expertise to examine in the light of their own several kinds of understanding (Appleton 1986: 32–34).

Scientists are not always good at doing this, because it means giving up a monopoly and opening the opportunity for others to share not only in the work but also in the credit, not to mention any financial rewards which might result from pursuing the idea further into the commercial field.

It is, then, a difficult territory into which we have dared to intrude. The distinction which I drew between cultural and natural symbolism seems to me to afford an opportunity for clarifying some of the problems, provided that we recognize its inevitable limitations. In the first place we must not confuse the distinction between artifacts and natural *objects* with the distinction between cultural and natural *symbols*. An eagle, for example, is a natural object. To a small rodent scurrying from one hiding place to another it is certainly a natural symbol also, a symbol of imminent danger requiring the most precipitous behavioral response. But when we see the eagle displayed on a flag, a coin or a coat of arms we may be sure it is discharging the function of a *cultural* symbol communicating a meaning with which it has at some time been invested by an act, or acts, of attribution.

Figure 55, on the other hand, shows an adventure playground for under-fives in the environs of Seattle, designed as an exercise by architectural students who had been introduced to the concepts of prospect, refuge and hazard by their instructors. Though a culturally devised object realized in a culturally determined idiom, it powerfully expresses an underlying symbolism which is of the *naturally* determined kind. It is about seeing-places, hiding-places, places for savoring danger from havens of safety, congregating-places, escape routes, and the spatial relationships between them, in short, the symbolism of strategic advantage and elementary survival-behavior.

An equally important point to remember is that artists in whatever medium do not exchange one kind of symbolism for another. Cultural and natural symbolism invariably supplement each other, as we saw in the case of Mr. and Mrs. Andrews (figure 42). There can be few more unequivocal examples of a *cultural* symbol than the scapegoat of the Jew-

FIGURE 55. Adventure Playground at Sand Point, Seattle, Washington. Photo by Jay Appleton.

ish tradition, a religious symbol of the expiation of the sins of the people which were ritually loaded on to it before it was, in one version of the story, thrown over a precipice to placate the demon of the wilderness. There is no reason why some other animal might not have been chosen, but, once the choice has been made, it becomes generally accepted as "correct." A "scapesheep" would sound as incongruous as the "Holy Pigeon."

The version in the sixteenth chapter of Leviticus is slightly different in that the goat was driven out into the wilderness to die of starvation. Before painting his well-known picture *The Scapegoat* (fig. 56), the Pre-Raphaelite painter Holman Hunt took great trouble to acquaint himself at first hand with the deserts of the Middle East so as to be able to contrive a wilderness sufficiently hostile to communicate spontaneously the message that it really was a place where biological survival was impossible—even for one of the hardiest animals of the known world. The richness of Hunt's prospect symbolism merely serves to reveal the absence of any visible sign, not only of refuge but of any potential source of sustenance. It is the symbolism of the deprivation-hazard at its most appalling.

I referred earlier to the dramatic hazard-symbolism in the work of John Martin, and before I close I should like you to see what happens when he tries to portray his vision of Elysium. William Feaver in his book on Martin says, "The setting of *The Eve of the Deluge* ... is the bland, widespread parkland which always served as Martin's Eden, Plains of Heaven and Rivers of Bliss" (Feaver 1975: 161).

So when we look at *The Plains of Heaven* (fig. 57) what do we find? Basically a combination of woodland and savannah, a landscape of grass and trees, embellished with floral and angelic decorations, perceived from a high, and therefore strategically superior vantage point commanding a broad prospect with a great depth of distance. Its numerous refuges range from shrublike vegetation, through shadows, to trees whose layering, like that of the ornamental cedar, is a powerful eye catcher. They are interconnected by clearly identifiable paths and passages. In the distance is the water, displayed in its two contrasting forms, the raging cataract and the tranquil lake, and beyond that the pyramidal peak, tantalizingly veiled in what Stephen and Rachel Kaplan call "mystery" (Kaplan and Kaplan 1982).

Let me leave you with two further visual images. The first you will

FIGURE 56. *The Scapegoat* by William Holman Hunt (1827–1910). An extreme representation of the symbolism of the "deprivation hazard." Reproduced by permission of National Museums and Galleries on Merseyside (Lady Lever Art Gallery, Port Sunlight, England).

Figure 57. *The Plains of Heaven* by John Martin (1789–1854). Reproduced by permission of the Trustees of the Tate Gallery, London.

FIGURE 58. *Landscape with a Castle*. The simple vernacular iconography is typical of a stereotyped class of pictures used to decorate narrowboats on English canals.

find on the network of English canals now virtually unused by the freight traffic for which they were constructed mostly between 1750 and 1830, but enjoying a huge revival for vacations. The old boatmen evolved a highly stereotyped style for decorating the tiny cabins of their working boats with paintings, almost all of which fell into one of two categories— floral designs, almost invariably roses, and castles, and these traditions have been perpetuated in the modern purpose-built vacation narrow-boats.

It is the castle pictures to which I refer as an example of a very simple vernacular art (fig. 58). They are executed with an extremely limited iconographic vocabulary comprising some seven items which we have already encountered, the castles themselves (with their prospect-refuge towers), water, small sailboats, bridges, open grassland, trees or shrubs, and distant pyramidal peaks. Often all seven are present; rarely less than five. Possibly to counterbalance the close confinement of the minute living space in those little narrowboats the symbolism tends to be rich in prospect, and trees, shrubs and bushes are sometimes dispensed with altogether.

Now compare these pictures with a landscape from the wall of a house in Pompeii (fig. 59), buried by the eruption of Vesuvius in 79 A.D. The castle is replaced by the temple, symbol of protection against powers spiritual rather than temporal. Note how its refuge values are enhanced by a canopy of arboreal foliage exactly like those rustic buildings in Barry's mural (fig. 1); and there is the water, there is the open ground, there is the bridge, and there are not one but two pyramidal peaks. As a matter of fact, in spite of the ravages of time, it is just possible to discern a third.

There is one other feature of this picture which I should particularly like you to note if you are still sceptical about the approach I have been putting forward in this book. Look at the temple and ask yourself this question. If this artist could competently and successfully employ the rules of perspective drawing well over a thousand years before they were first rationally understood and mathematically explained by Brunelleschi, Alberti, and their contemporaries, may it not be that artists portraying landscape in whatever medium have for centuries been working equally successfully with a symbolic system which we are only now beginning to understand?

FIGURE 59. Landscape depicted on a mural from Pompeii (pre-79 A.D.). Reproduced by courtesy of Museo Nazionale, Naples.

Nobody objects to the idea that even the greatest artists are constrained by the laws of the mathematical and the physical sciences. Even abstract artists acknowledge such fundamental concepts as the vertical and the horizontal, direct expressions of the laws of gravity, and the right angle in which they intersect, not to mention the colors of the spectrum or the rules of harmony. All that I am now suggesting is that artists may be equally constrained, whether they realize it or not, by the laws of the *biological* sciences, and that, if they are, we ought to widen the field of aesthetic enquiry to comprehend these laws also. Is that such a terrible thing?

# NOTES

1. See, for instance, Ardrey's *African Genesis* (1958), *The Territorial Imperative* (1967), *The Social Contract* (1972) and Morris's *The Biology of Art: A Study in the Picture-Making Behaviour of the Great Apes and Its Relationship to Human Art* (1962), *The Naked Ape: A Zoologist's Study of the Human Animal* (1967), *The Human Zoo* (1969), *Manwatching: A Field Guide to Human Behaviour* (1977) and *The Soccer Tribe* (1981).

2. *The Encyclopedia Britannica* (15th edition, 1985), *Micropedia,* s.v. "aesthetics," says of Alexander Gottlieb Baumgarten (1714–1762) that he coined the term "aesthetics" and established this discipline as a distinct field of philosophical enquiry. "He both advanced the discussion of such topics as art and beauty and set the discipline off from the rest of philosophy." But "only later was the term aesthetics restricted to questions of beauty and the nature of the fine arts."

3. I am grateful to Dr. Megan Clive of Ottawa for helpful suggestions about the terminology of landscape description.

4. I am grateful to Dr. Judith Bryce of the Department of Italian, the University of Hull, for drawing my attention to this passage.

5. It is clearly not practicable to restate here all the arguments put forward in *The Experience of Landscape*. Where they are necessary for an understanding of the present discussion, certain ideas from that book have been introduced at the appropriate point. For a comprehensive account of "habitat theory" and "prospect-refuge theory" the reader is referred to the 1986 reprint (see list of references), but a more concise and partially updated review may be found in Appleton (1984).

6.
> Sempre caro mi fu quest'ermo colle,
> e questa siepe, che da tanta parte
> dell'ultimo orizzonte il guardo esclude.
> Ma sedendo e mirando, interminati
> spazi di là da quella, e sovrumani

silenzi, e profondissima quiete
io nel pensier mi fingo; ove per poco
il cor non si spaura.

I am grateful to Brian Moloney, Professor of Italian at the University of Hull, for drawing my attention to this poem.

7.                             Es schienen so golden die Sterne,
                              Am Fenster ich einsam stand
                              Und hörte aus weiter Ferne
                              Ein Posthorn im stillen Land.
                              Das Herz mir im Leibe entbrennte,
                              Da hab ich mir heimlich gedacht:
                              Ach, wer da mitreisen konnte
                              In der prächtigen Sommernacht!
                                   (J. F. Eichendorff, *Sehnsucht*)

# REFERENCES

Allan, D. G. C. n.d. *The Progress of Human Knowledge: A Brief Description of the Paintings of James Barry in the Lecture Hall or "Great Room" of the Royal Society of Arts.* London: R. S. A. (Abridged from Barry's own account in the society's library).

Appleton, Jay. 1975. *The Experience of Landscape.* London and New York: Wiley. Reprint. Hull: Hull University Press, 1986.

———. 1978. *The Poetry of Habitat.* Hull: Hull University, Department of Geography, and Landscape Research Group.

———. 1980. *Landscape in the Arts and the Sciences.* Hull: Hull University Press.

———. 1984. "Prospects and refuges re-visited," *The Landscape Journal* 3:91–103.

———. 1986. "The Role of the Arts in Landscape Research." Penning-Rowsell and Lowenthal: 26–47.

Balling, J. D., and J. H. Falk. 1982. "Development of Visual Preference for Natural Environments." *Environment and Behavior* 14:5–28.

Barrell, John. 1972. *The Idea of Landscape and the Sense of Place, 1730–1840: An Approach to the Poetry of John Clare.* Cambridge: University Press.

Bell, Clive. 1914. *Art.* London: Chatto and Windus.

Börsch-Supan, Helmut. 1972. "Catalogue." In *Caspar David Friedrich, 1774–1840: Romantic Landscape Painting in Dresden.* London: The Tate Gallery, 51–101.

Brotherton, Ian. 1986. "Critiques and Queries." In *Landscape Meanings and Values,* edited by Edmund Penning-Rowsell and David Lowenthal, 22–23.

Burke, Edmund. 1757. *A Philosophical Enquiry into the Origins of Our Ideas on the Sublime and the Beautiful.* London.

Campbell, H. J. 1973. *The Pleasure Areas.* London: Eyre Methuen.

Clare, John. 1935. *The Poems of John Clare.* Ed. J. W. Tibble. London: Dent.

Cosgrove, Denis. 1980. "Images of Landscape." In *An introduction to behavioural geography,* edited by J. R. Gold. Oxford: OUP.

———. 1984. *Social Formation and Symbolic Landscape.* London and Sydney: Croom Helm.

———. 1986. "Critiques and Queries." In *Landscape Meanings and Values,* edited by Edmund Penning-Rowsell and David Lowenthal: 23.

Daniels, S. and D. Cosgrove. (eds.) 1988. *The Iconography of Landscape.* Cambridge: CUP.

# REFERENCES

Eitner, Lorenz. 1955. "The Open Window and the Storm-tossed Boat: An Essay in the Iconography of Romanticism." *Art Bulletin* 37:281–90.

*Encyclopedia Britannica,* 1974 and 1985 editions. Chicago.

Feaver, William. 1975. *The Art of John Martin.* Oxford: Clarendon Press.

Gear, Jane. 1989. *Perception and the Evolution of Style: A New Model of Mind.* London: Routledge.

Gibson, J. J. 1979. *The Ecological Approach to Visual Perception.* Boston: Houghton Mifflin.

Hospers, John. 1967. "Aesthetics, Problems of." In *The Encyclopedia of Philosophy,* edited by Paul Edwards. New York: Macmillan and the Free Press.

Humphrey, Nicholas. 1972. "The Illusion of Beauty." *Perception* 2:429–39.

Jacob, François. 1982. *The Possible and the Actual.* Seattle and London: University of Washington Press.

Jenkins, Iredell. 1958. *Art and the Human Enterprise.* Cambridge, Mass.: Harvard University Press.

Kaplan, Stephen and Kaplan, Rachel. 1982. *Cognition and Environment.* New York: Praeger.

Langer, Susanne K. 1953. *Feeling and Form: a Theory of Art Developed from Philosophy in a New Key.* London: Routledge and Kegan Paul.

Meinig, D. W. 1979. "The Beholding Eye." *The Interpretation of Ordinary Landscapes,* edited by D. W. Meinig. Oxford: University Press, 33–48.

Morse, Douglass. 1980. *Behavioral Mechanisms in Ecology.* Cambridge, Massachusetts: Harvard University Press.

Novak, Barbara. 1980. "On Defining Luminism." In Wilmerding, J. et al. *American Light: the Luminist Movement, 1850–1875.* Washington D.C.: National Gallery of Art.

Orians, Gordon H. 1980. "Habitat Selection: General Theory and Applications to Human Behavior." In *Evolution of Human Social Behavior,* edited by J. Lockard. New York: Elsevier, 49–66.

———. 1986. "An Ecological and Evolutionary Approach to Landscape Aesthetics." In *Landscape Meanings and Values,* edited by Edmund Penning-Rowsell and David Lowenthal, 3–25.

Paulson, Ronald. 1982. *Literary Landscapes: Turner and Constable.* New Haven: Yale University Press.

Penning-Rowsell, Edmund and David Lowenthal, eds. 1986. *Landscape Meanings and Values.* London: Allen and Unwin.

Richter, Jean Paul. 3d ed. 1970. *The Literary Works of Leonardo da Vinci, Compiled and Edited from the Original Manuscripts by Jean Paul Richter.* London: Phaidon.

Sassoon, Siegfried. 1938. *The Old Century.* London: Faber and Faber. Reprint, Faber, 1980.

Sibley, Frank. 1965. "Aesthetic and Non-aesthetic." *Philosophical Review* 74:135–59.

Tatarkiewicz, Wladyslaw. 1972. "The Great Theory of Beauty and its Decline." *Journal of Aesthetics and Art Criticism* 31:165–80.

Wilton-Ely, John. 1978. *The Mind and Art of Giovanni Battista Piranesi.* London: Thames and Hudson.

# INDEX

Abstract art, 105
Acropolis, Athens, 95 (fig. 54)
Adventure playgrounds, 97, 98 (fig. 55)
Aesthetic: myth, 16; priesthood, 16, 17, 20; values, xi, 15, 16, 20, 24, 71–72
Aesthetics, 19, 107
Affordance, 24, 47
Alberti, Leone Battista, 103
Alcázar, Segovia, Spain, 48 (fig. 21)
Allan, D. G. C., 4, 109
Ambivalence, 25, 88, 89 (fig. 50)
American Naturalist School. *See* Dewey, John
Animism, 33
Anticipation (prediction), 33, 34, 38
Appleton, Jay, xi, 25, 32, (fig. 5), 33–34, 37, 60, 93, 97, 107, 109
Archetypes, 15
Architects and architecture, 37, 39–40, 54, 60, 83, 97
Ardrey, Robert, 9, 107

Balling, J. D., 15, 109
Balmoral Castle, Scotland, 60
Barrell, John, 94, 109
Barry, James, 4, 5 (fig. 1), 6, 26, 28, 103
Bell, Clive, 17, 109
Bellini, Giovanni, 37–38
Börsch-Supan, Helmut, 78, 109
Bosch, Hieronymus, 83
Brain, 13–14, 21
Breughel, Pieter, 39
Briançon, France, 68 (fig. 38)
Bridges, 66, 103
Brontë, Emily: *Wuthering Heights,* 35

Brotherton, Ian, 72, 109
Brown, Lancelot (Capability), 73
Brunelleschi, Filippo, 103
Budapest, Hungary, 51 (fig. 24)
Buildings as symbols, 47
Burke, Edmund, 13, 109

Cairo, Egypt, 50 (fig. 23)
Campbell, H. J., 14, 15, 28, 109
Canadian Group of Seven, 39
Canal art, 102 (fig. 58), 103
Caravaggio, Michelangelo Merisi da, 88
*Carceri d'Invenzione* (Piranesi), 83, 86–87 (figs. 48–49), 88
Castles, 102 (fig. 58), 103. *See also* Fortifications; Alcázar; Balmoral; Chillon; Craigievar
Caves, 54, 57 (fig. 29)
Cézanne, Paul, 39, 42 (fig. 17)
*Chiaroscuro,* 88, 90 (fig. 51), 93
Chillon, Château de, Switzerland, 62 (fig. 33)
Clare, John, 93–94, 109
Claude (Lorrain), 39, 41, (fig. 16)
Claustrophobia, 54
Constable, John, 66, 83
Cosgrove, Denis, 9, 10–12, 109
Craigevar Castle, Scotland, 63 (fig. 34)
Cromford Mill, Derbyshire, 47, 55 (fig. 27)
Cultural symbolism. *See* Symbolism, cultural
Cuyp, Aelbert, 89 (fig. 50)

Dali, Salvador, 39
Daniels, Stephen, 9, 11, 109
Darwinism, 12, 18–19, 22
Deflected vistas, 60, 67–69 (figs. 37–39)

# INDEX

Delacroix, Eugène, 81 (fig. 44)

Delhi, India, 47, 55, 56 (fig. 28), 61 (fig. 32)

Dewey, John, xi, 15

Eichendorff, Joseph Freiherr von, 78–79, 108

Eitner, Lorenz, 78–79, 110

Evolutionary change, 12–13

Expectation. *See* Anticipation

Exploration, 25, 27, 38

Falk, J. H., 15, 109

Feaver, William, 83, 99, 110

Foraging-grounds, 7, 14, 27

Fortifications, 39, 45 (fig. 20), 46, 47, 54, 55 (fig. 27), 60

Freiburg-im-Breisgau, Germany, 49 (fig. 22)

Friedrich, Caspar David, 78, 80 (fig. 43)

Frost, Robert, 36

Gainsborough, Thomas, 30, 76, 77 (fig. 42), 83, 97

Gear, Jane, 34–38, 110

Gibson, J. J., 24, 110

Habitat, 7, 14, 24, 76: of *homo sapiens,* 14–15

Harris, Lawren, 43 (fig. 18)

Hazards, 25, 46, 79, 81–82 (figs. 44–45), 83–88 (figs. 46–49), 89, 94, 97; deprivation, 99–100; impediment, 54, 58 (fig. 30), 61 (fig. 32), 66; breaches in, 66

Here and there theme, 33–34, 79

Hiding. *See* Refuge

Hokusai, Katsushika, 39

Horizons, 28, 32–40, 60

Hospers, John, 17–18, 110

Hudson, Thomas, 27, 31

Hull, England, 52 (fig. 25), 57–58 (figs. 29–30), 65 (fig. 36)

Humphrey, Nicholas, 21, 110

Hunt, William Holman, 99 (figs. 56), 99

Inversion, 93

Jacob, François, 12, 13–14, 20–21, 110

Jenkins, Iredell, 18–19, 110

Kaplan, Stephen and Rachel, 100, 110

Kent, William, 73

Landscape: architectuure, 37, 72–76; definition of, 11, 21; evaluation, 23, 71

Langer, Susanne K., 96, 110

Language, 18, 23, 24, 26, 33

Le Nôtre, André, 73

Le Puy, France, 44 (fig. 19)

Leonardo da Vinci, 25

Leopardi, Giacomo, 36

Lowenthal, David, 109–110

Luminism, 18

Martin, John, 83, 84–85 (figs. 46–47), 99, 101 (fig. 57)

Masses, 69, 73

Meinig, Donald, 16, 110

Metaphor, 18, 96

Morris, Desmond, 9, 107

Morse, Douglass, 6, 110

Muncaster Castle, Cumbria, 67 (fig. 37)

Mystery, 99

Natural symbolism. *See* Symbolism, natural

Nature-versus-nurture, 72, 76

Neo-Impressionism. *See* Pointillism

Nesting-places, 7, 14, 27, 47

Nottingham, England, 54, 59 (fig. 31)

Novak, Barbara, 18, 110

Open window. *See* Eitner, L.

Orians, Gordon H., 12, 15, 39, 110

Orientation, 7, 38

Parkland, 15

Paulson, Ronald, 83, 110

Peaks, conical, pyramidal, 39, 41 (fig. 16), 42 (fig. 17), 43 (fig. 18), 44 (fig. 19), 45 (fig. 20), 99, 103

Pelvoux, Massif du, France, 69 (fig. 39)

Penetrability, 54, 58–59 (figs. 30–31)

Penning-Roswell, Edmund C., 109–110

Perspective drawing, 103

Piranesi, Giovanni Battista. *See Carceri d'Invenzione*

Pleasure, 14, 15, 28: and displeasure, 14–15; as motivation, 22, 38, 79

Pointillism, 20

Pompeii, 103, 104 (fig. 59)

Portraiture, 27, 88

Precipices, 45 (fig. 20), 46

Prediction. *See* Anticipation

Preference, 6–7, 71

Prisons, 54. *See also* Piranesi, G. B.

# INDEX

Prospect and refuge, 25–26, 29–30, 35, 46, 54, 73, 76, 79, 88–89, 93, 94, 97, 99, 103

Questionnaire methods, 71

Red Fort. *See* Delhi, India
Reflecting glass (in buildings), 60, 65 (fig. 36)
Refuge, 53 (fig. 26), 54, 60, 76. *See also* Prospect and refuge
Religious paintings, 4
Rembrandt van Ryn, 88
Repton, Humphry, 73
Richter, Jean Paul, 25, 110
Rivers, 66, 88
Romanticism, 73, 79, 83
Route selection, 60, 66
Royal Society of Arts, 4, 5 (fig. 1), 6, 109
Ruisdael, Jacob van, 88, 91–92 (figs. 52–53), 93

San Marino, 39, 45, (fig. 20), 46, 96
Sassoon, Siegfried, 28, 33, 37, 110
Savannah, 15, 99
Scapegoat, 97, 99–100 (fig. 56)
Scottish Baronial Style, 54, 63–64 (figs. 34–35)
Sibley, Frank, 17, 110
Site selection, 7

Skinner, B. F., 19
*Son et lumière,* 93, 95 (fig. 54)
Storm-tossed boat. *See* Eitner, L.
Survival behavior, 7, 97
Symbolism (symbols), 3–9, 94, 96, 97: cultural, 8, 26, 46, 49–52 (figs. 22, 23, 24, 25), 73, 76, 78, 96, 97; natural, 8–9, 23, 24, 26, 46, 93, 96, 97

Tatarkiewicz, Wladislaw, 21, 110
Towers, 46, 49–52 (figs. 22, 23, 24, 25), 54, 60, 64, (fig. 35)
Territorial attraction, 14
Turner, J. M. W., 82 (fig. 45), 83

Vernacular art, 103
Vernet, Horace: *The Battle of Montmirail,* 38, 40 (fig. 15)
Versailles, 72–73, 74–75 (figs. 40–41)
Voids, 69, 73

Water, 88, 89 (fig. 50), 99. *See also* Rivers
Weald (Kent), 28
Wijnants, Jan, 29
Wilson, Richard, 41 (fig. 16)
Wilton-Ely, John, xii, 83, 110